CREATIVE
PEP TALK

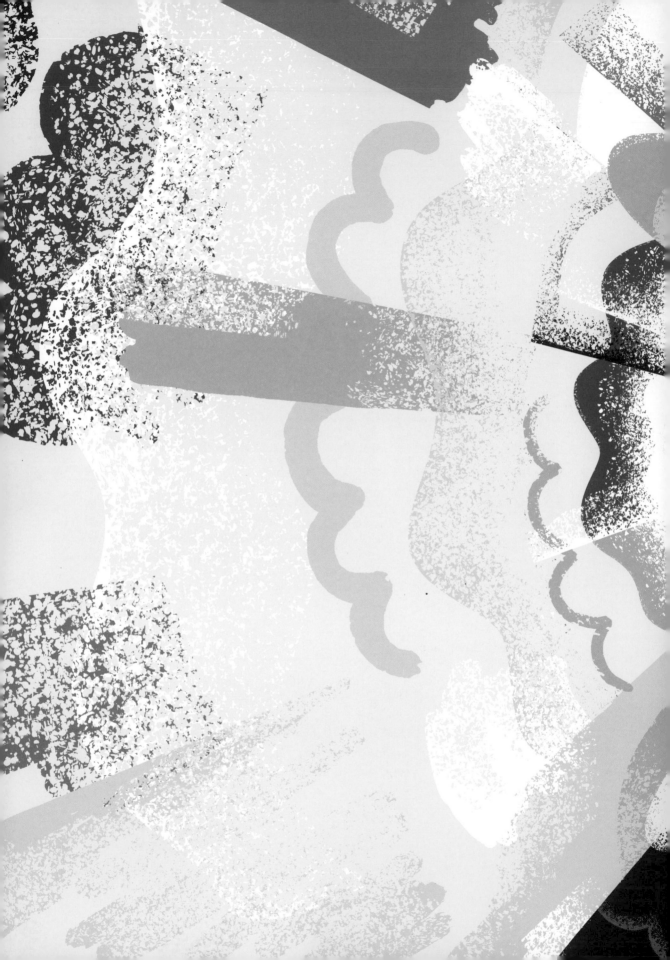

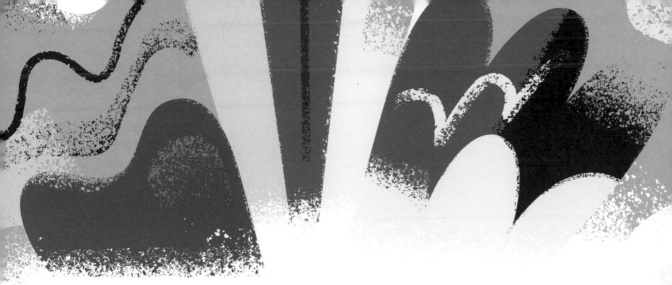

CREATIVE
PEP TALK

INSPIRATION FROM **50** ARTISTS

BY ANDY J. MILLER
INTRODUCTION BY BRANDON RIKE

CHRONICLE BOOKS
SAN FRANCISCO

Library of Congress Cataloging-in-Publication Data:
Title: Creative Pep Talk : Inspiration from 50 artists / preface by Andy J.
Miller ; foreword by Brandon Rike.
Description: San Francisco : Chronicle Books, [2017]
Identifiers: LCCN 2016019503 I ISBN 9781452152080 (hardcover : alk.
paper)
Subjects: LCSH: Commercial artists. I Inspiration in art.
Classification: LCC NC1001 .C74 2017 I DDC 741.6092/2--dc23 LC
record available at https://lccn.loc.gov/2016019503

Manufactured in China

Design by Andy J. Miller

10 9 8 7 6 5 4 3 2 1

Chronicle Books LLC
680 Second Street
San Francisco, California 94107
www.chroniclebooks.com

TO MY
WIFE SOPHIE,
THE ONE WHO
PEP TALKS
THE PEP
TALKER

TABLE of CONTENTS

PREFACE

WHY A PEP TALK?

BECAUSE THRIVING AS A CREATIVE PERSON ISN'T ABOUT LUCK OR TALENT.

IT'S ABOUT BLOOD, SWEAT, & TEARS. PUTTING IN the HOURS, STAYING MOTIVATED ON A DAILY BASIS, & STAYING DEDICATED TO PERFECTING YOUR CRAFT OVER A LIFETIME.

THE WORLD ISN'T READY FOR YOUR CREATIVITY BECAUSE IT DIDN'T EXIST UNTIL NOW. THERE'S NO COOKIE-CUTTER SHAPE FOR YOU TO FILL IN; YOU HAVE TO MAKE YOUR OWN SPACE & MOLD IT TO YOUR UNIQUE FORM.

OH, AND ALL the WHILE, ALL SORTS OF PEOPLE WILL BE TRYING TO STOP YOU. ENEMIES, FRIENDS, & EVEN YOUR FAMILY WILL TRY & "SAVE" YOU FROM YOUR CREATIVE PATH.

TO BE HONEST, IT'S AN UPHILL BATTLE.

BUT YOU CAN DO IT. IT TAKES CLARITY & STRATEGY, DISCIPLINE & GRIT. SOMETIMES IT EVEN TAKES LONG NIGHTS & TAKE-OUT PIZZA.

JOKING ASIDE, I HOPE THIS BOOK ACTS AS YOUR PERSONAL PEP RALLY, CHEERING YOU ON IN THIS CREATIVE RACE.

DO WHATEVER IT TAKES TO STAY PEPPED UP!

-ANDY J. MILLER

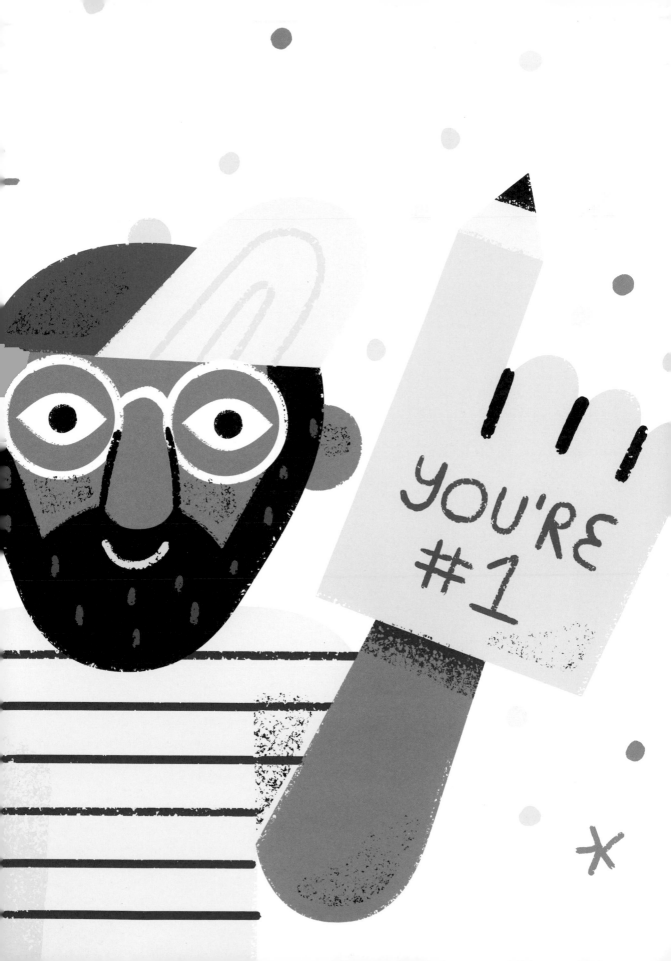

INTRODUCTION

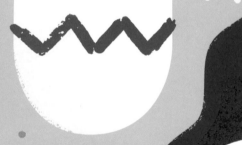

While the word *pep* is not the first one I would use to describe my mission amidst a global creative community, it's simply a different name for the same thing. Whether the word is *pep*, *inspiration*, *optimism*, *persistence*, *dedication*, *effort*, *excitement*, or any other synonym you can find in the thesaurus, the sentiment is the same: In order to achieve and maintain success in a creative field, you must prioritize enthusiasm. As idealistic as it may seem to expect people to keep smiles on their faces, a deep exhaustion only reminds us of its importance. A career spent extracting every last creative molecule from our brains on a daily basis tends to drain us so completely that we must have another motivation beyond money or deadlines.

Gratitude is necessary in creative fields. There is an imperative to appreciate the fact that our work is born out of our talents, as opposed to our obligations. We draw pictures for a living. If that isn't a reason for our heads to explode every day, then I just don't know what is.

But this creativity comes with an emotional price. What we make often comes from such a personal place, and is such a representation of ourselves, that putting it out for approval and having it criticized can feel as though we are constantly allowing ourselves to be disrespected and prodded on a daily basis.

But that's not what is actually occurring. We are being creatives for a living, and we often wear our hearts on our sleeves. Revision requests are not an attack on our humanity; rather, they are another cog in the creative machine. A little self-talk can remind us of this process and give us the courage and enthusiasm to push on.

Sometimes, it may just take a little creative pep talk to get us through.

—BRANDON RIKE
FREELANCE GRAPHIC ARTIST
HOST OF THE GRAPHIC
SOUND *PODCAST*

RILLA ALEXANDER

DONE IS BETTER THAN NONE

When I was seven, I penciled the first picture book that I didn't finish. I expected it to turn out better than it seemed it would.

That process of getting from the dreaming to the doing has proved a continual challenge for me. Eventually I realized I wasn't going to get anywhere while I had my expectations set so high.

Rather than setting out to create a masterpiece . . . I just had to aim for "done."

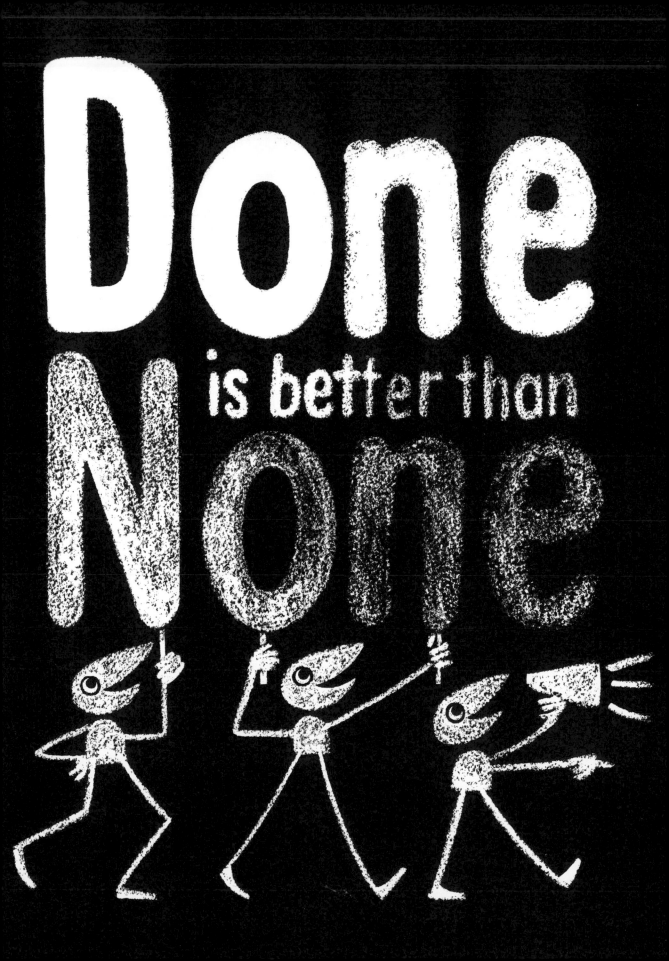

STEVE ALEXANDER

LESS TALK, MORE ACTION

We all know it's far easier to talk about what we are going to do than it is to actually do it. Whether it is enthusiastic declarations of plans for personal projects or endless committee meetings, we can get lost in a cycle of discussion where little is achieved. Commit to a direction. Do it!

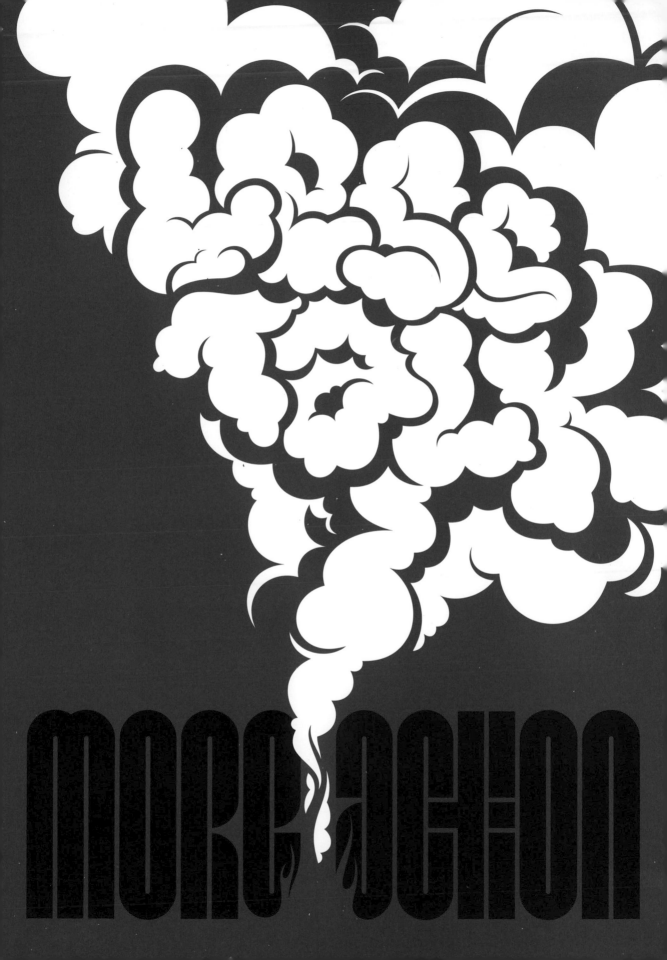

ALWAYS WITH HONOR

DESIGN TAKES TIME

A successful design should be the culmination of a myriad of approaches and solutions explored, a patchwork of both good and bad ideas. Don't beat yourself up if the solution isn't immediately in your lap; it's not always meant to be that simple.

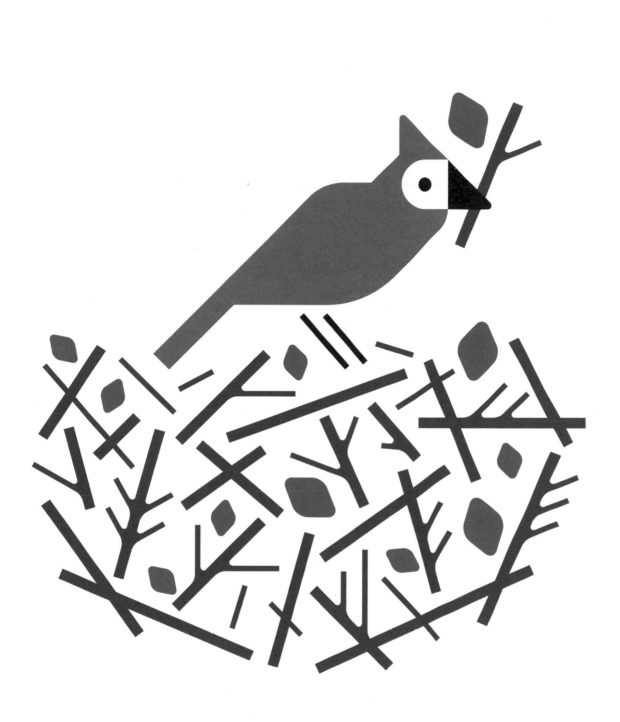

DESIGN TAKES TIME

CHUCK ANDERSON

LET'S DO SOMETHING IMPOSSIBLE

This piece was created for the Chicago Design Museum. Several artists were asked to work with the phrase "Let's Do Something Impossible" to create posters that would be given away to the museum's Kickstarter contributors. I love the line. It's so succinct yet it's a very strong call to action full of optimism. I wanted to merge very graphic, almost violent imagery of flowers with these words—it just felt like a good dichotomy. Beautiful yet chaotic and challenging at the same time. I think any creative person can relate to the feeling of having to achieve something impossible and going through the chaos to see the beauty and the color on the other side.

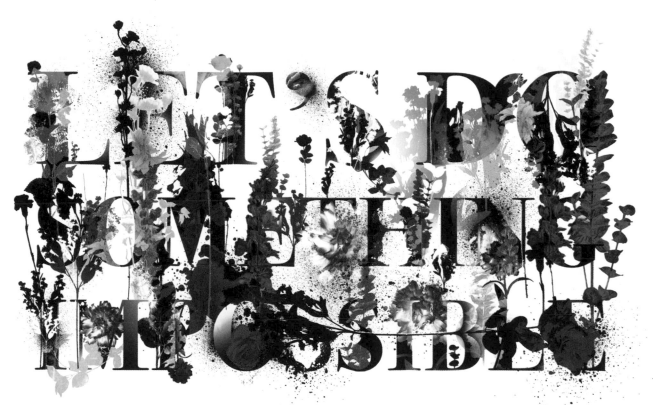

KATE BINGAMAN-BURT

EVERYONE HAS A STORY TO TELL

It's easy to forget that we do. It's easy to get caught up with trends. It's easy to lose our own voice. But it's worth remembering and repeating: Everyone has a story to tell. What's yours?

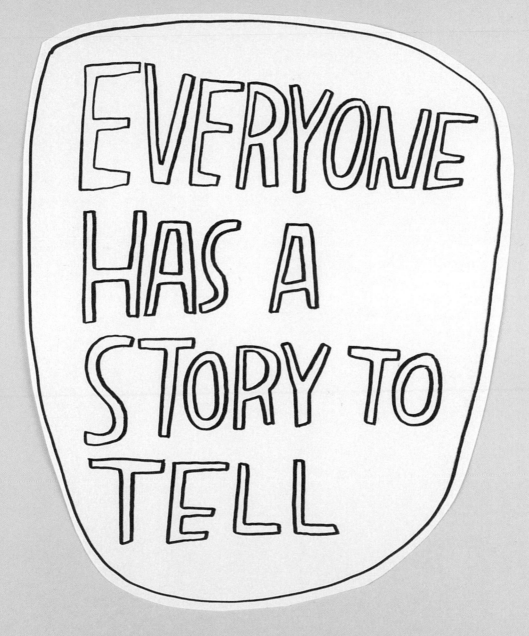

DARREN BOOTH

EMBRACE CREATIVE SELF-RELIANCE

To me, this simply means that one should look inward for inspiration and influence instead of looking outward. Look at prior artistic successes and failures and grow from them.

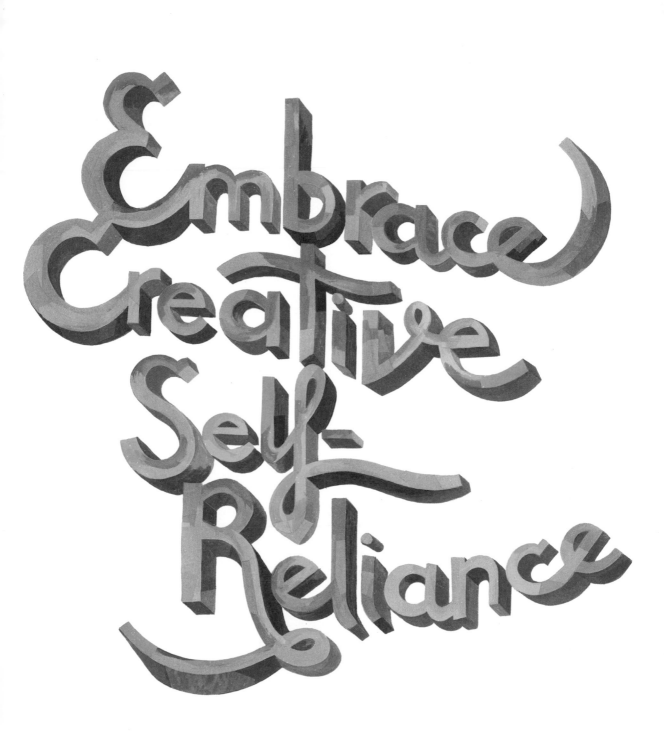

WILL BRYANT

I MAKE STUFF BECAUSE I GET SAD IF I DON'T

This is a simple but never truer sentiment.
I originally came up with this phrase in
2008 and have since drawn multiple
iterations. If I'm bummed out, it's probably
because I haven't made anything in a
while. Sometimes I'm bummed out by
what I make, but the act of making is still
crucial to my happiness.

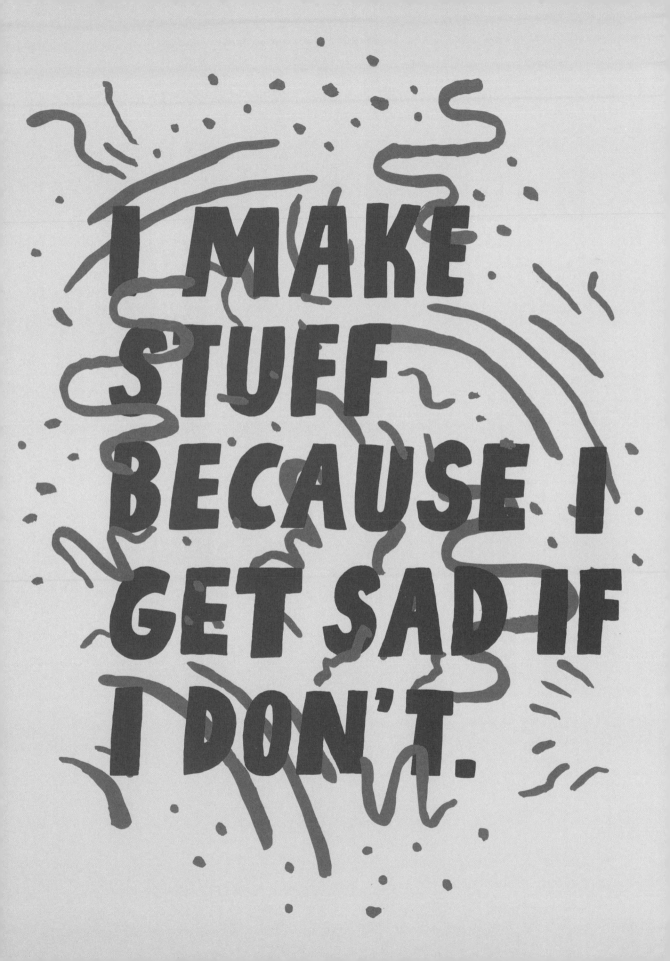

BUILD

LISTEN + OBSERVE

Listen . . .

The ability to listen and observe is a very important one in design . . . and in life in general. How do we solve a client's problem if we do not first understand the problem? Let the client talk, let him/her talk some more, ask questions, and listen. To fully engage with someone is not just to talk; sometimes it's sitting back and letting him/her talk. To be a good listener is a valuable trait in a person, and an invaluable quality in a designer.

Observe . . .

People watching is fun, and in a studio, it's a good way of seeing how people deal with people, how they deal with situations (both good and bad). To be an observant person is also a valuable trait, not only in watching people, but also in observing the world around you. Open your eyes; look up, down, left, and right. A keen observer can introduce the multitudes of input into his/her work, allowing for a richer visual experience. Observe, write stuff down, take pictures, ask questions.

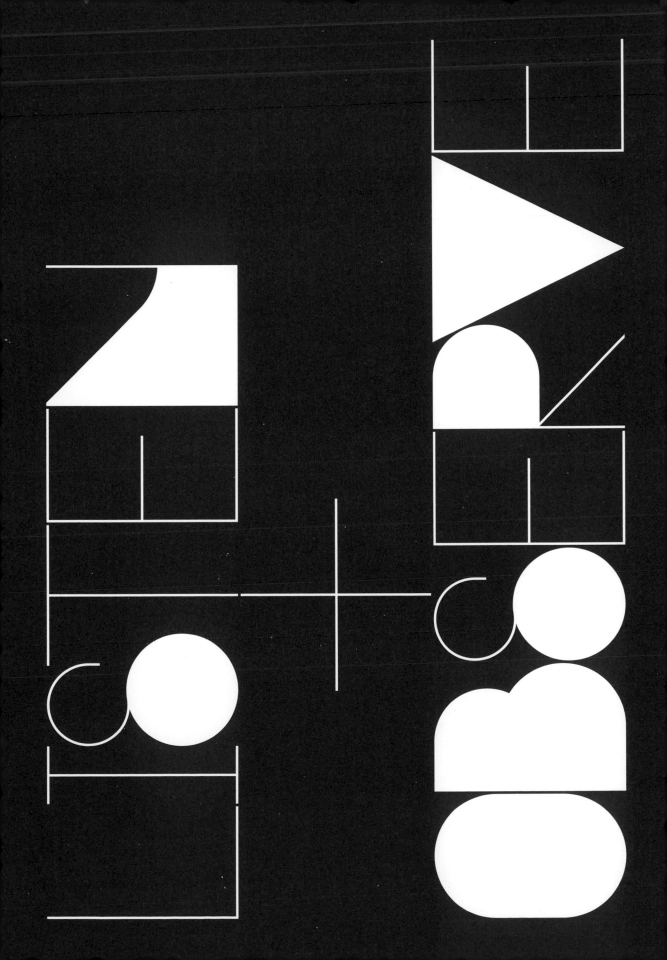

JON BURGERMAN

IF YOU CAN'T BE GOOD, BE DIFFERENT

It's tough being the best, mainly because there's not really any such thing. There's always someone you perceive as being better. We shouldn't get too wrapped up in all that because it makes us and our work boring. I believe it's better to focus on being different, or in other words, being you. Being interesting and offering an unusual point of view through your work is more valuable than being technically proficient. So don't worry about being as good, or the best, just be interesting and different!

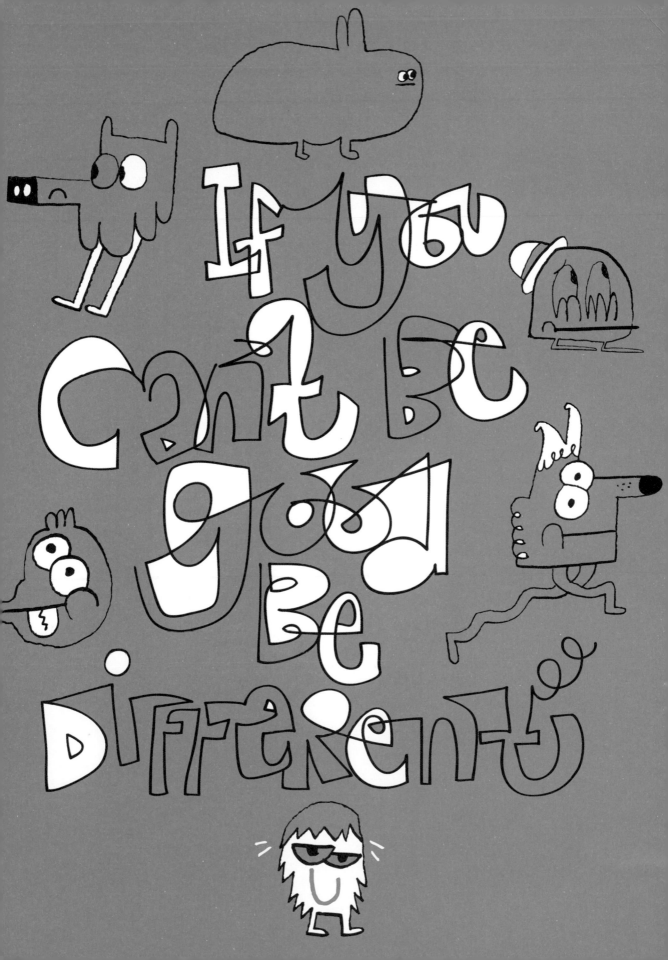

WILL WORK FOR WORK

If you look at the landscape of design today, you'll notice the trend of self-motivated work. Designers, illustrators, and all sorts of creative people are not just waiting around for dream clients. They are dreaming up passion projects and bringing them to fruition with their own blood, sweat, and tears. Through these labors of love, employers, art directors, and possible clients may see how passionate you are about your profession and want to work with you.

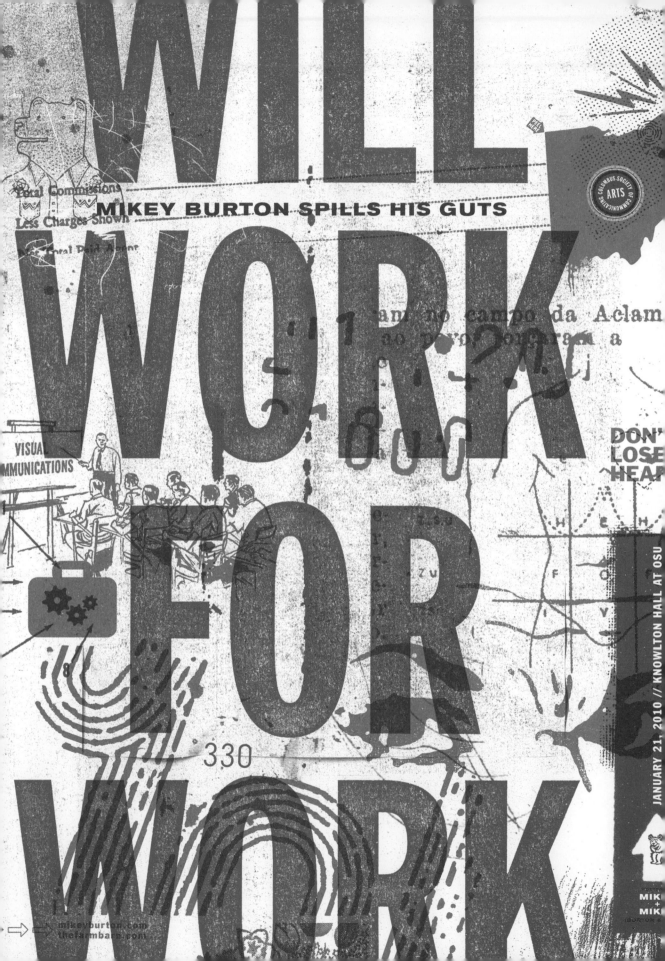

TAD CARPENTER

TOGETHER

There is great value in feeling a part of a team. As humans, we want to be part of a group that is larger than ourselves, whether that's a family, a sports team, or even a profession, we want to be part of a group. As a designer, at times, it can feel like a very isolating profession. It's as if we woke up on Christmas morning, and the entire McCallister family has left for Paris, and we find ourselves home alone. For me, the best work I create is always when I make an effort to collaborate with the others involved in the project and the others in my studio. As designers we are not just little Kevin McCallisters, working all alone. We are collaborators, colleagues, and team members working together to make our place a better place.

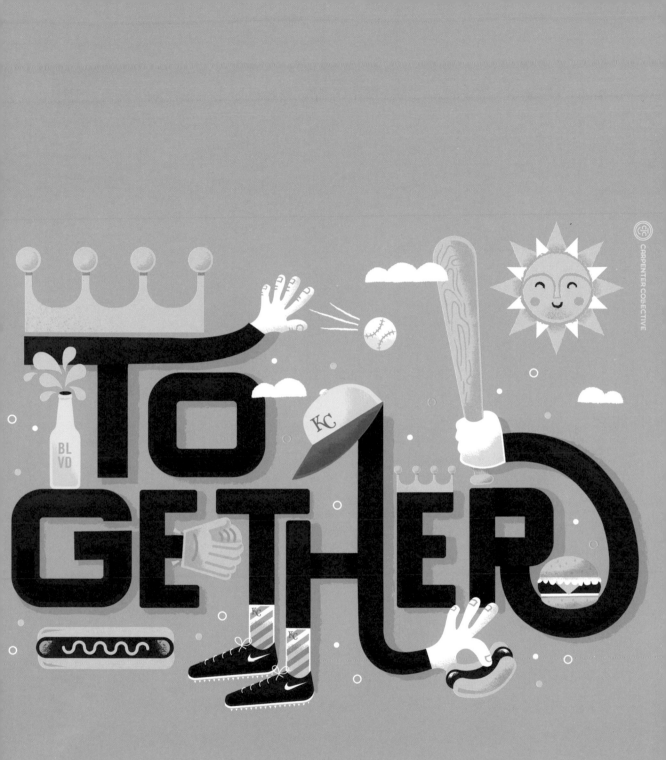

DAN CASSARO

PROMISE TO STAY WILD

This might sound like an empty youthful platitude, but it's something I find myself holding closer the older I get. Things get comfy as you get older, and getting comfortable is the death of creativity. I keep this as a battle cry to stay sharp, weird, and open to the new.

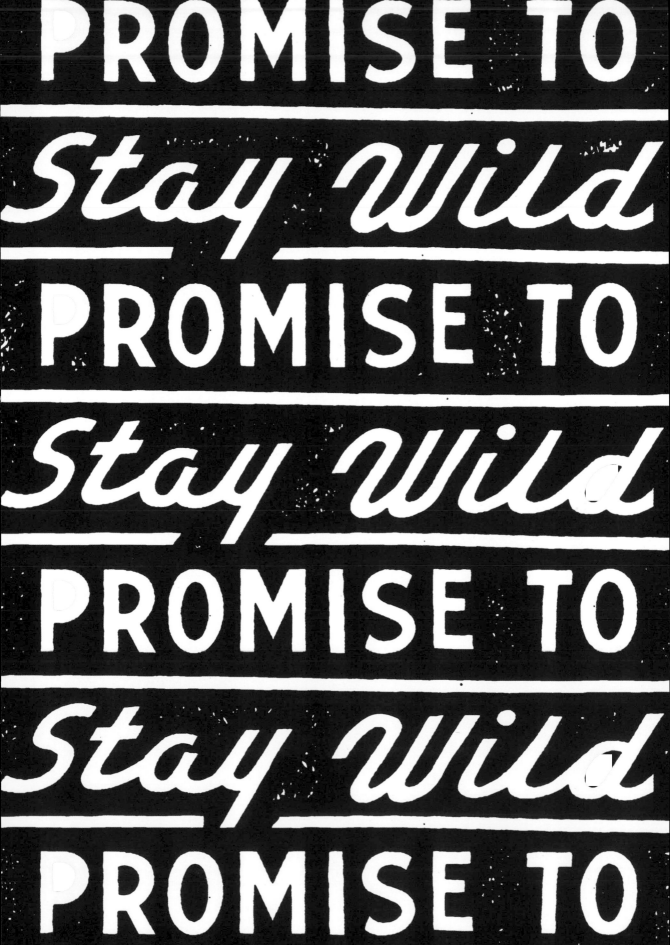

DAN CHRISTOFFERSON

BURN BRITE THROUGH THE NIGHT

There are a lot of little hacks we can use to access those parts of our minds that hold creative solutions. The one I find the most helpful is cruising that blurry border between asleep and awake and exploiting it to get at all those subconscious goodies.

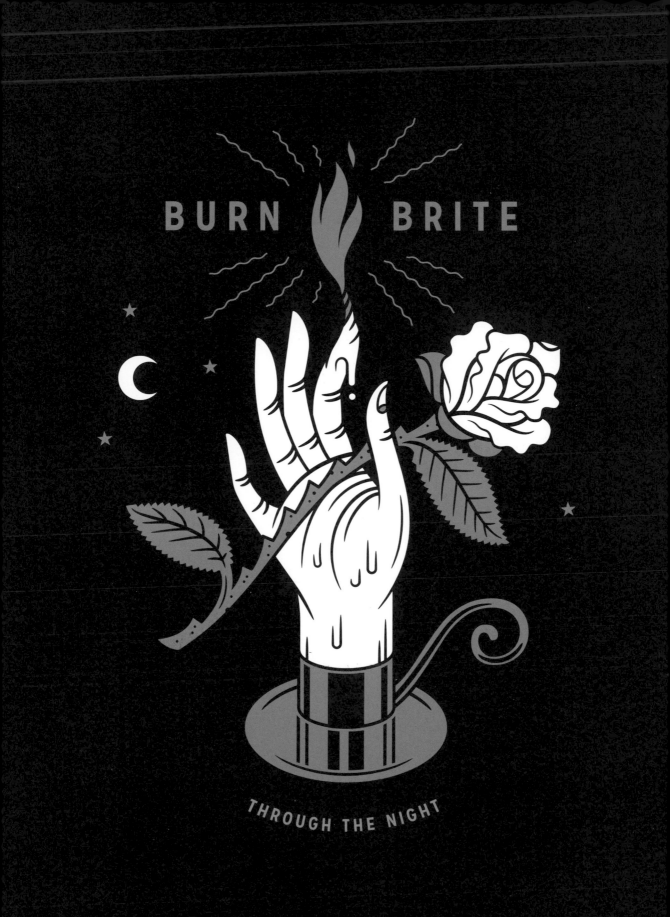

LISA CONGDON

IT'S ALWAYS WORTH IT

I spent much of my life until my late thirties lamenting mistakes and harboring regrets. Somewhere in there, I learned that what made me feel better each day was embracing everything about my life, including the things that didn't go well. This simple perspective shift changed everything for me and made it much more possible for me to feel happy every day. It also helped me take more risks, because even if I failed, it would be worth it since I would learn something new that made me a better, smarter, more compassionate person. I came up with this phrase to remind myself and others of this way of thinking. This is the fourth piece of artwork I've designed with the phrase since 2008.

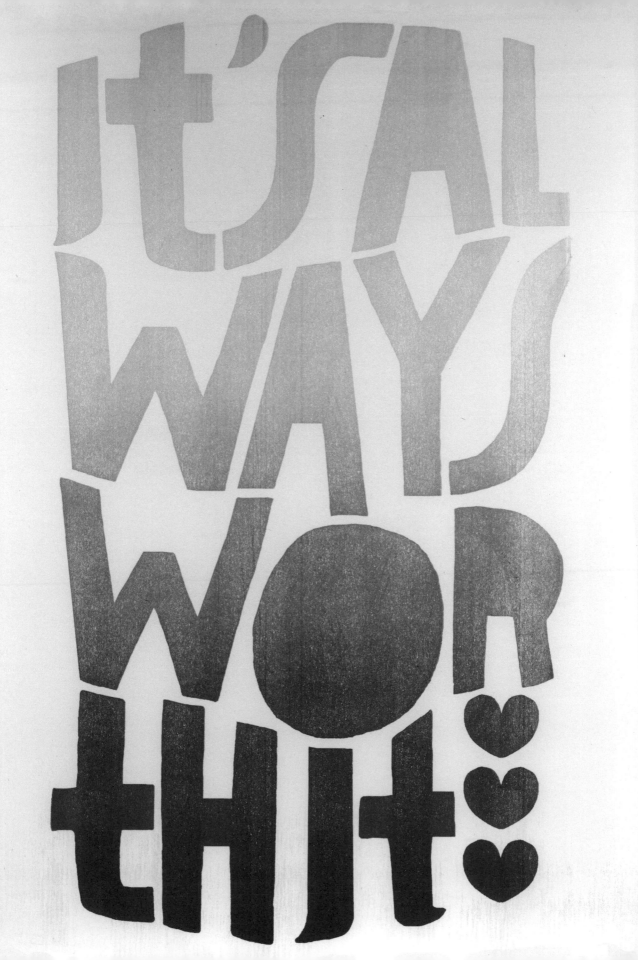

JON CONTINO

DESIGN MAKES EVERYTHING POSSIBLE

Everything in this world is made possible
by design. Without it, we have nothing.

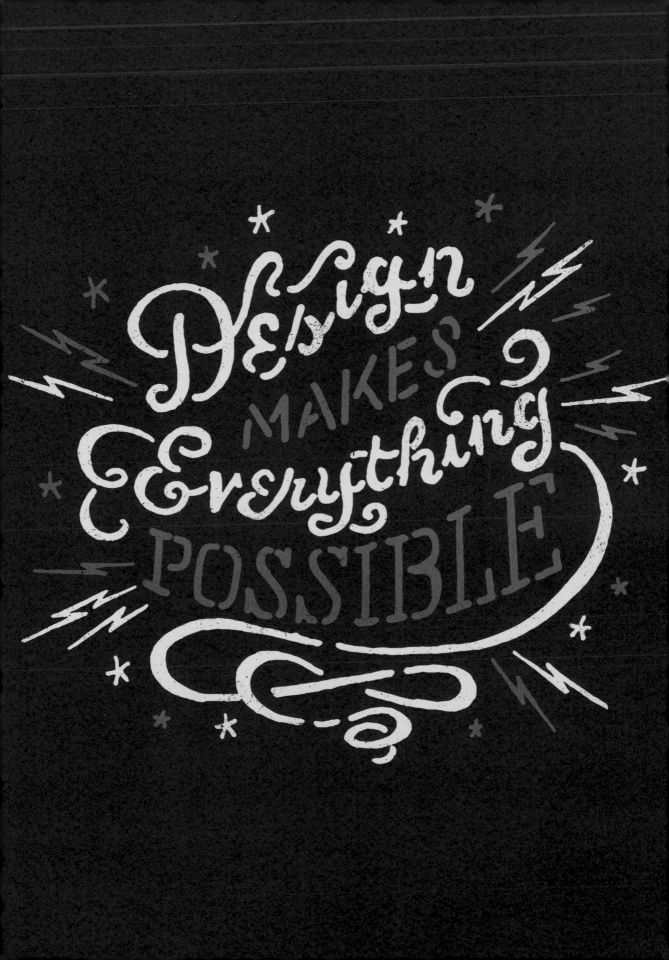

HELEN DARDIK

BE BRAVE, BE STRONG

We all need some bravery in our lives.
Fear of failure cripples creativity, leaving
you staring at a blank page unable to
start. . . . So one has to be brave in order
to create. Being brave is being afraid
but doing it anyway. So . . . be brave! Be
strong and be creative!

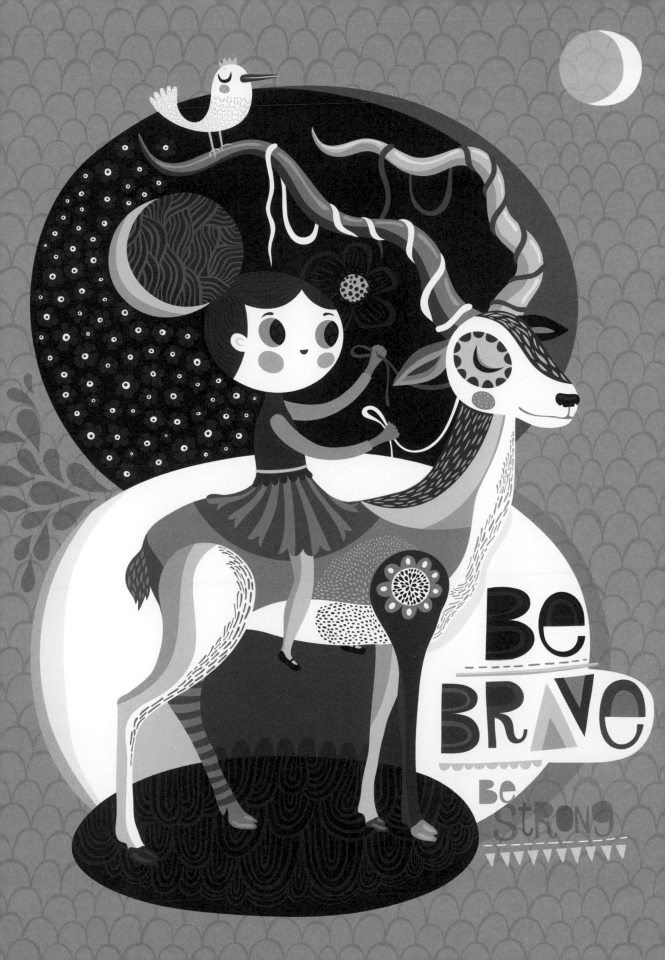

AARON JAMES DRAPLIN

GET COSMIC

Right now, right this very second . . . as your hands turn the pages of this book . . . Right this very second . . . the universe is expanding into, uh, *something*. Or is it expanding into *nothing*? Does the universe have an edge? Or does it just go on and on forever and ever, making it up as it goes? Say you go in one direction all the way to the edge of the universe, do you just sort of slam into a wall of non-existence? This. This stuff. This is the stuff I think about and freak out about. Hourly. In fact, I can't believe people don't completely lose their shit over this more often. We're a speck within a speck within a speck of our little corner of the universe. And I'm worried about prime mark abuse, why my eyebrows hurt, just why the hell Guy Fieri exists? And the best part? The universe doesn't revolve around us. We're just one little grain of sand, whirring along in space with everything else. And how the hell can we be alone in it? How pompous of us to concoct that selfish story here on Earth.

I think if humankind would think just a little bit bigger, we would get past all the bullshit difference we keep hanging on to here on Earth. We should be thankful any of us exist in the first place. I find this staggering insignificance rather inspiring. I'm proud to be a part of it. Get cosmic!

Here's a little quote by Arthur C. Clarke that always stuck with me:

"Sometimes I think we're alone in the universe, and sometimes I think we're not. In either case the idea is quite staggering."
—Arthur C. Clarke

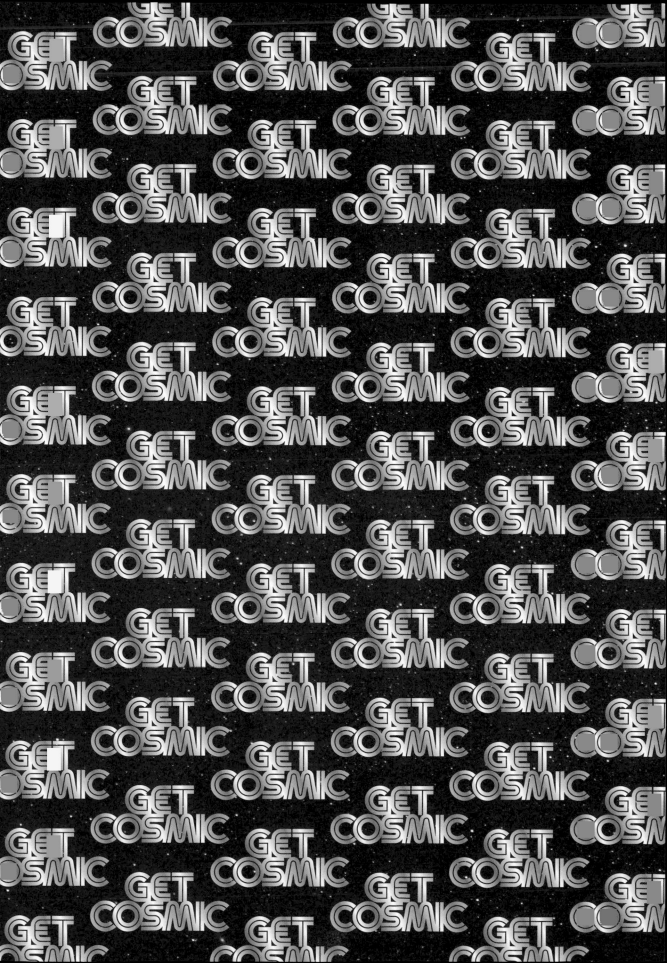

JOEY ELLIS

HAVE NO FEAR

Fear of rejection or failure can be debilitating, but when you consider how short life is, you're able to manage those fears and use them as motivation. You will be gone and forgotten soon enough, so why not make a splash while you can? Stare fear in the face and move forward.

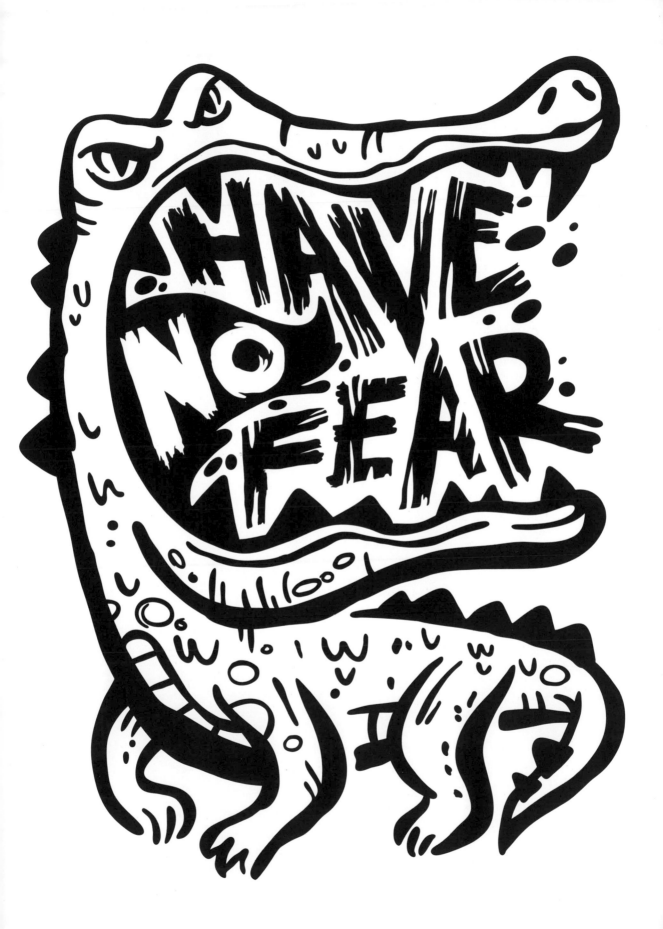

DANIELLE EVANS/ MARMALADE BLEUE

LIVE YOUR DREAM

Lettering, especially the dimensional variety, brings design to life and sharply into focus. While the final looks playful and simple, this project was anything but easy. After experiencing a family death the morning of the shoot, a tedious studio day, and unforeseen environmental conditions that ruined the first execution, I was heavily discouraged. Thankfully, my clients believed in me and invited me to try a second round.

I realize the statement "Live Your Dream" often passes from our lips in a syrupy, vapid manner. In actuality, professional lettering often means giving your best effort when it's neither convenient nor easy to do so. This often means fostering focused play and leaning into setbacks. To work by hand, artists have to believe they can improve upon what they've created and rebuild whatever breaks along the way. This project taught me that perseverance can build a better image, one that all parties can celebrate, which is in fact the dream.

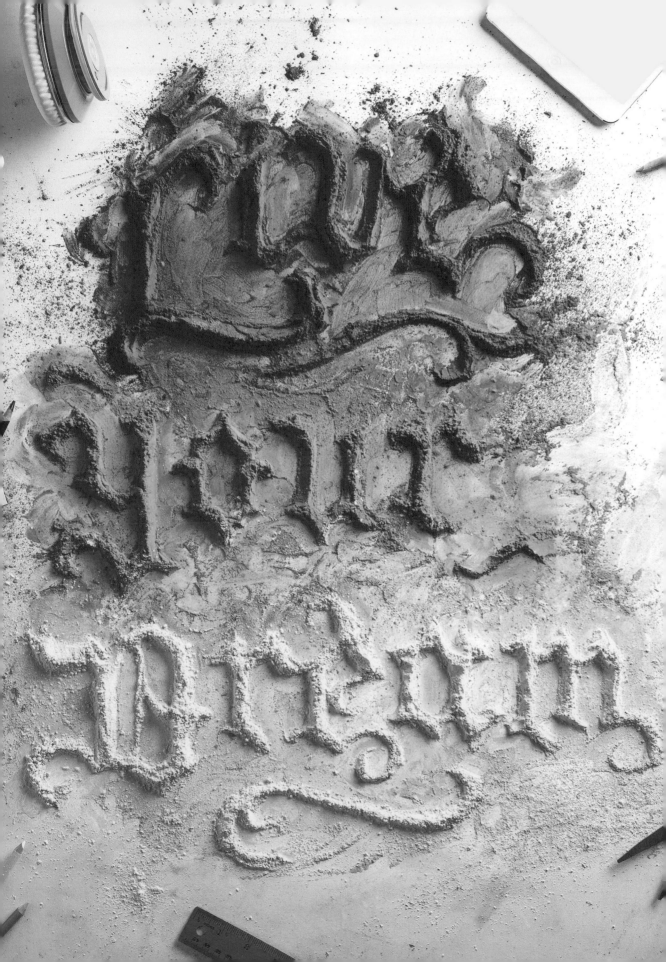

BOB EWING

TURN A NEGATIVE INTO A POSITIVE

I think just having a positive outlook on life/work in general goes a long way. We can learn a lot about ourselves from adversity, and that is how we grow as creatives and human beings. Keeping that in mind when going through difficult situations allows us to focus on how we can get better, instead of sulking in a negative vibe.

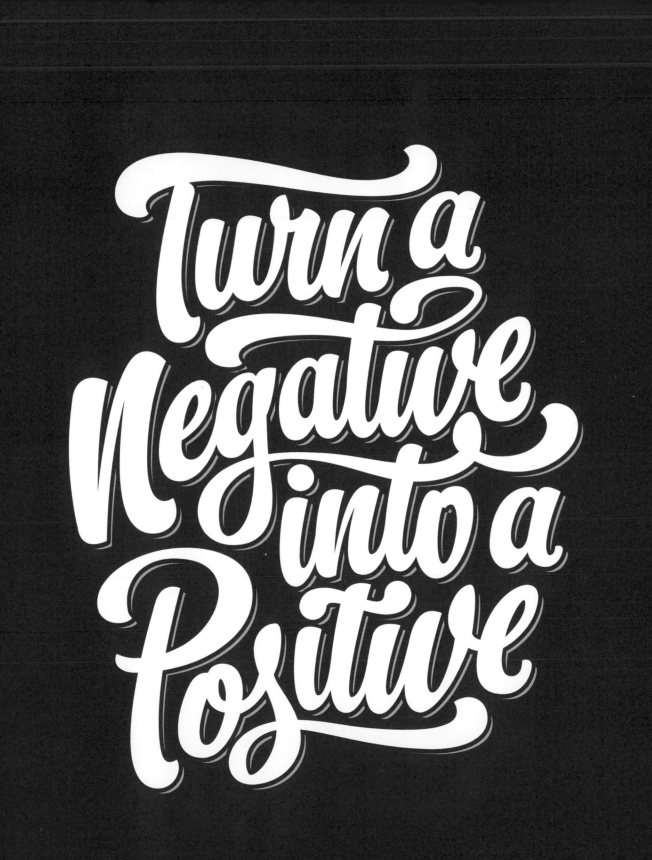

YOU'LL NEVER FEEL READY, SO YOU MIGHT AS WELL PUT YOURSELF OUT THERE

A few years ago, Marshall Arisman told me, "You'll never feel ready, so you might as well put yourself out there." As young creative people, we often get caught up in whether or not we are good enough to pursue a professional practice. We sit alone working all day and all night with little to no insight into whether what we are doing is good or has any value. The way to solve these insecurities comes down to three simple steps:

1. Message three friends. Sometimes we look at a new piece or complete a series/portfolio of images, and we become overwhelmed by it. Asking three people you trust to give feedback or even simply asking them if your work is good is enough to make you feel excited about sharing it with everyone.

2. Internet high fives. Putting your work on the Internet is a good way to get instant approval from friends, family, and fans who follow you. Don't get too

hung up on numbers though. Forty people "liking" or "favoriting" an image should feel as good or successful as four thousand people liking it. In the end, someone took three seconds to look, take in what they saw, and press a button to say "I like it."

3. Send it off to people who could hire you. . . . Maybe. I am not saying that you should send a sketchbook drawing to an art director or art buyer. What I am saying is that if you make a piece of art that you like and other people like, why not send it to people who may hire you? Maybe in an email or a postcard.

Ultimately you don't know how someone who is in a position of hiring will receive it. It comes down to you feeling good about what you make. And if you feel great about what you create, someone else will see that passion and hire you for what you love to do.

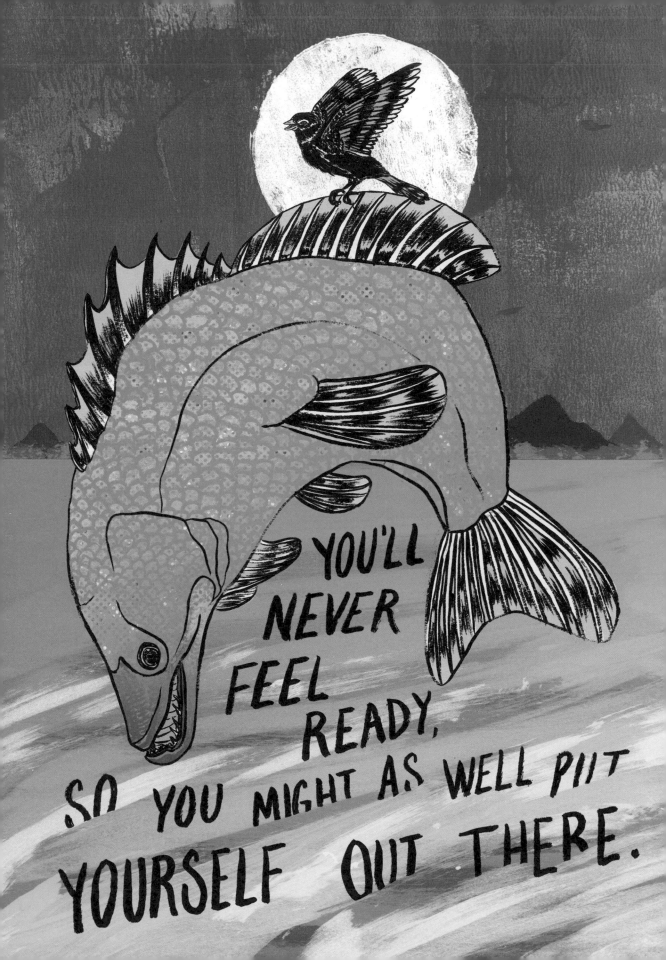

ADAM R. GARCIA/ THE PRESSURE

THE PRESSURE IS GOOD FOR YOU

This is a phrase that does double duty for my studio, The Pressure. It serves not only as a motivational phrase (obviously) but also as a pervasive business slogan (in a Trojan-horsey way). We've been lucky with the life that it has had beyond the studio slogan, and I'm definitely happy that others find its sentiment as exciting as I do.

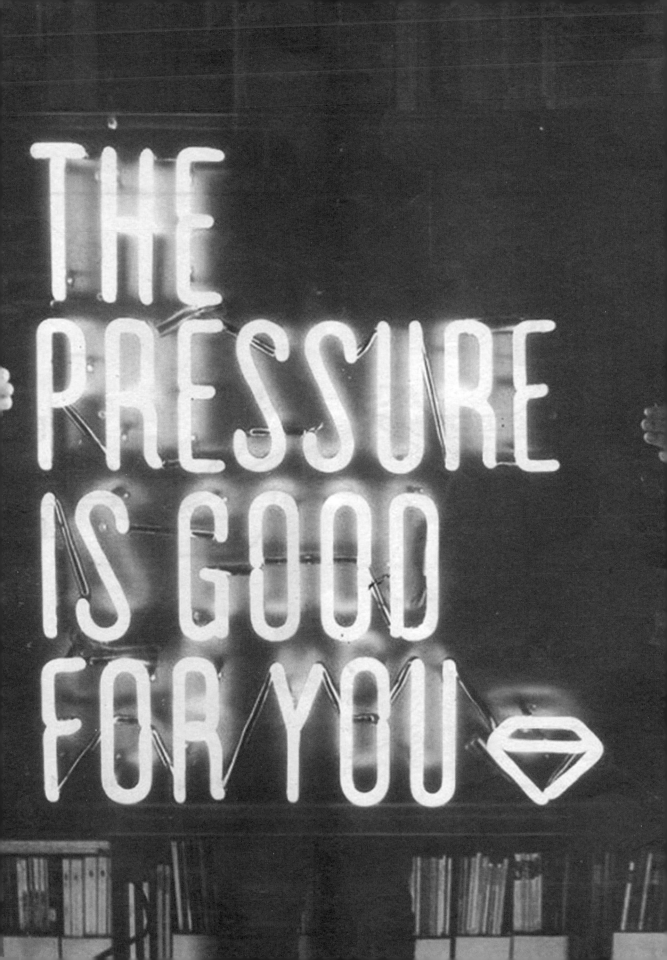

TIMOTHY GOODMAN

THE MORE YOU FIND YOURSELF, THE MORE FRIENDS YOU'LL LOSE

A year and a half ago, I started two different Instagram writing pieces. The first is called "Memories of a Girl I Never Knew," which are longer vignettes that I write very seriously about my thoughts and past mistakes with women and relationships. The second and more light-hearted series is something I call "Instatherapy." They are short phrases or maxims that I write and post sparingly. And this phrase is one of them.

Writing is something I've always gravitated toward, something I've always felt comfortable with, something I've always practiced. I like what it means to work with my fears and my insecurities. I want to come clean about myself, I want to be as vulnerable as possible, and I want to share that vulnerability with an audience. It's been an honor to see how much these projects have resonated with people.

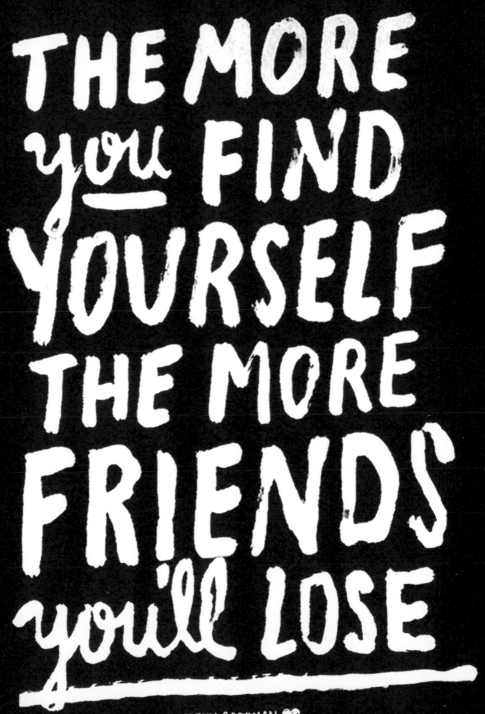

THE MORE YOU FIND YOURSELF THE MORE FRIENDS YOU'LL LOSE

TIMOTHY GOODMAN

ROB HODGSON

CHILD IS FATHER OF THE MAN

This means the kid in you is who your adult self grew out of. I know it from a Beach Boys song of the same name, but I believe it's originally from a Wordsworth poem.

Being a good guide to the visual world by feeding kids the good stuff is something I try to remember when I make work. I also try to remind myself and other adults that the fire that got you going when you were a kid is still there to get you excited and to reconnect with. Climb that tree! Play that song! Pet that animal! Otherwise I don't know how anyone deals with the real-life adult world.

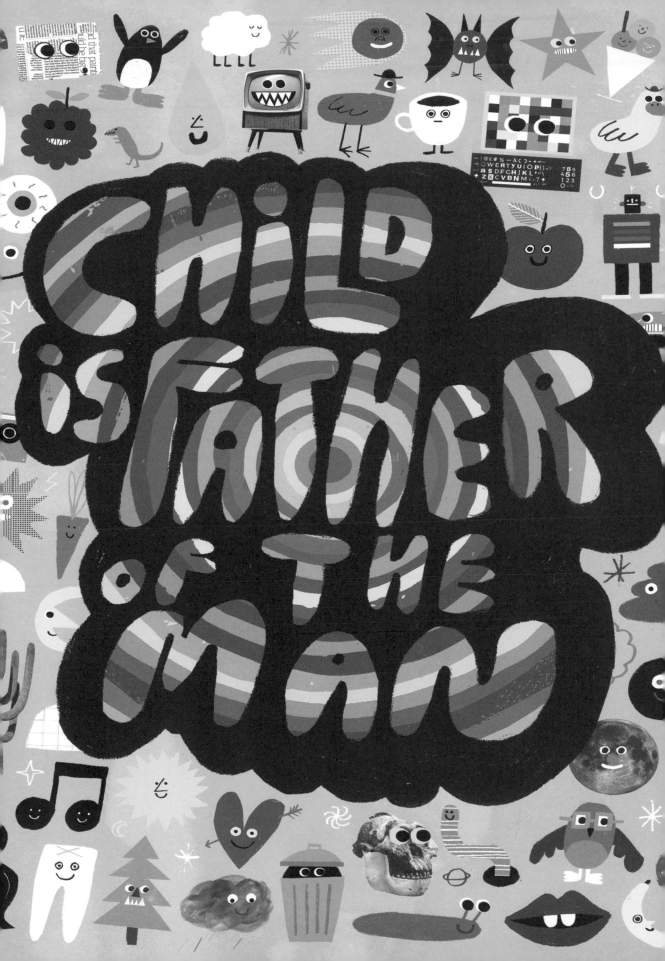

YOU CANNOT LIVE YOUR WHOLE LIFE IN COMFORT ZONES

Something that I never could've anticipated in my creative practice is the fact that I crave growth. It's often uncomfortable and sometimes scary to push into unknown or weak areas, but I get restless if I stay in the same creative place too long. I'm a big proponent of lifelong learning and experimentation. Evolution and reflection are really key to my process. It's good to spend some time in areas where you're comfortable to grow and make your skills solid, but if you stay in one place too long you'll never get to explore the ideas just outside your periphery.

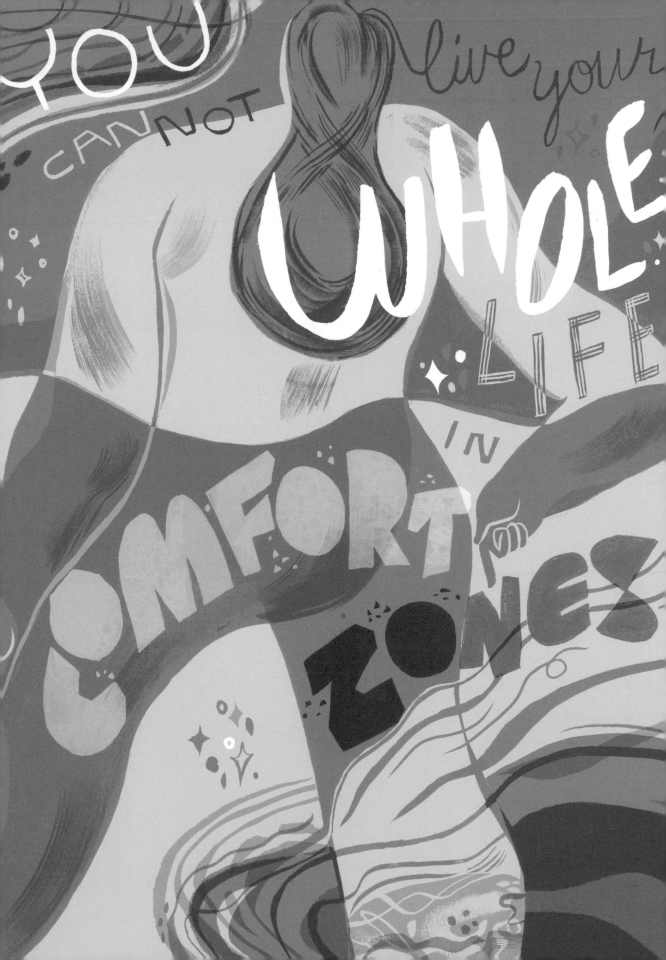

ERIN JANG

MAKE WORK PLAY

Having fun when I'm working, looking at a project in a playful way, and making things with my hands have all been successful approaches to design for me. Some of my favorite projects have come from a place of play. Experimenting with collage led to some award-winning designs at *Esquire*. Fooling around with food faces with my son turned into a column for *Lucky Peach* and a fun project with Disney. Making and designing gifts for my family and close friends led to being approached to write a craft book. Making your designs playful and bringing that joy of creating and experimenting into a project can make your work sing.

OLIVER JEFFERS

CREATE CURIOSITY

This was created as a charitable endeavor to support education. It's a mixed-media piece with drawn, painted, and collaged elements, which is fairly common across much of my body of work. I have always found curiosity to be among the most important elements of any child's growth and development, especially within the context of education, and I hope that my work has been able to inspire a curious spirit within growing minds.

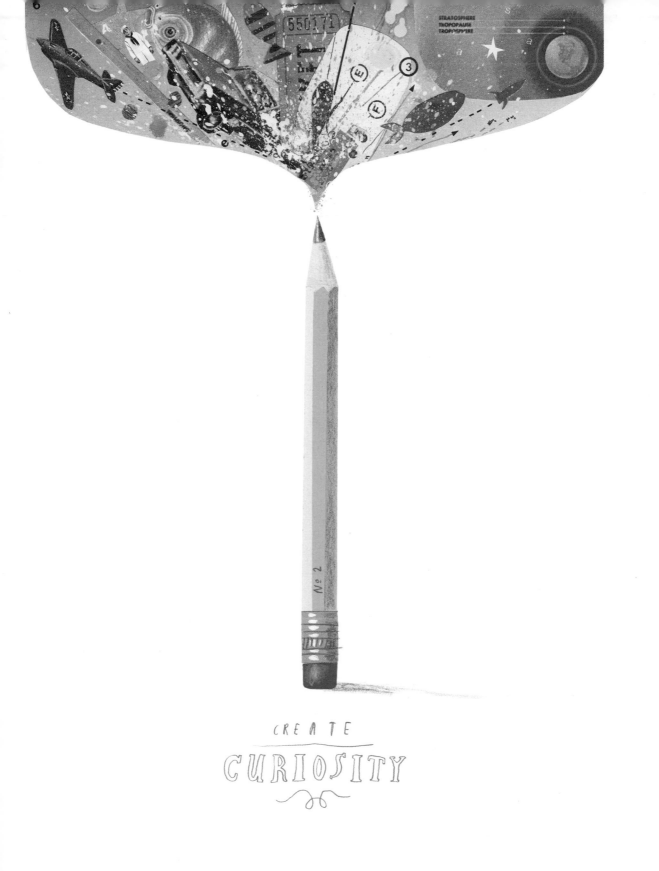

CREATE
CURIOSITY

JOLBY & FRIENDS

DISCOVER SOMETHING

As creatives, we get very caught up in our heads with trying to find the right idea within the first minute of conception and then get frustrated when it's not there. We forget that we need to dive deeper and work with others to chisel away at an idea, to try new things, and to get out of our comfort zones. Only then can we discover something new and worth doing.

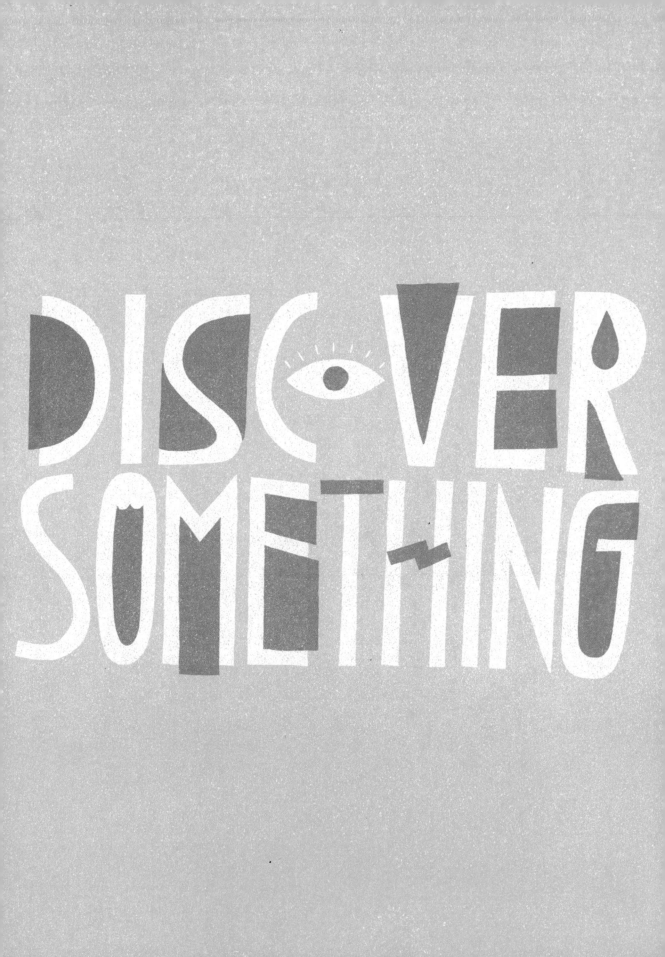

LITTLE FRIENDS
of PRINTMAKING

LEARN TO SAY "NO"

For years, we had a note with the command "Learn to Say NO" hanging over our desk. As young designers trying to establish ourselves, we had the deeply counterproductive tendency to say "Yes" to any opportunity, regardless of its value. It didn't matter whether an opportunity was a total time waster, whether it lined up with our short-term or long-term goals, whether it took us away from our core practice—we acted as if turning down any offer would signal to the world that we didn't want to work. It took us years to put our new motto into practice, but once we did, everything changed for us. Respecting your own talent and time is a huge key to avoiding burnout and making time for the projects that can actually sustain a career.

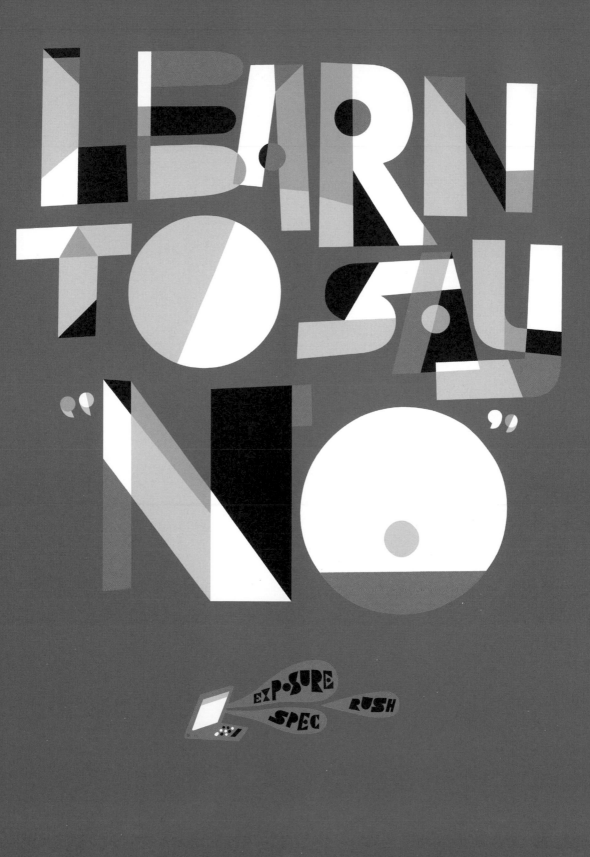

LEARN TO SAY "NO"

EXPOSURE SPEC RUSH

ERIK MARINOVICH

LIVE BIG BY APPRECIATING ALL THAT IS SMALL

Learn how to turn work off and wake up to a moment. Be open to those fleeting conversations, use a Sharpie on your favorite shirt, play an instrument even if you don't know how. These small moments can inspire you in surprising ways and might even lead to an idea of a lifetime.

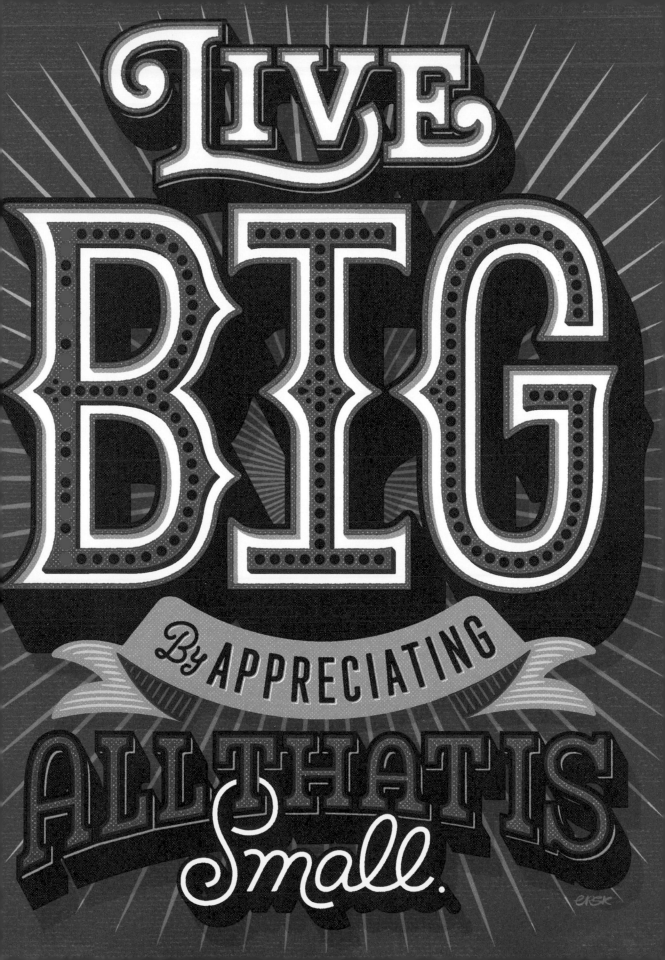

MARY KATE McDEVITT

ROLL WITH IT & GAIN MOMENTUM

I've never been great at planning ahead, so I've learned to go with the flow and take things as they come, but that does very little if you aren't taking chances or learning along the way. It's important to keep making progress and staying sharp. This message is a good reminder of that.

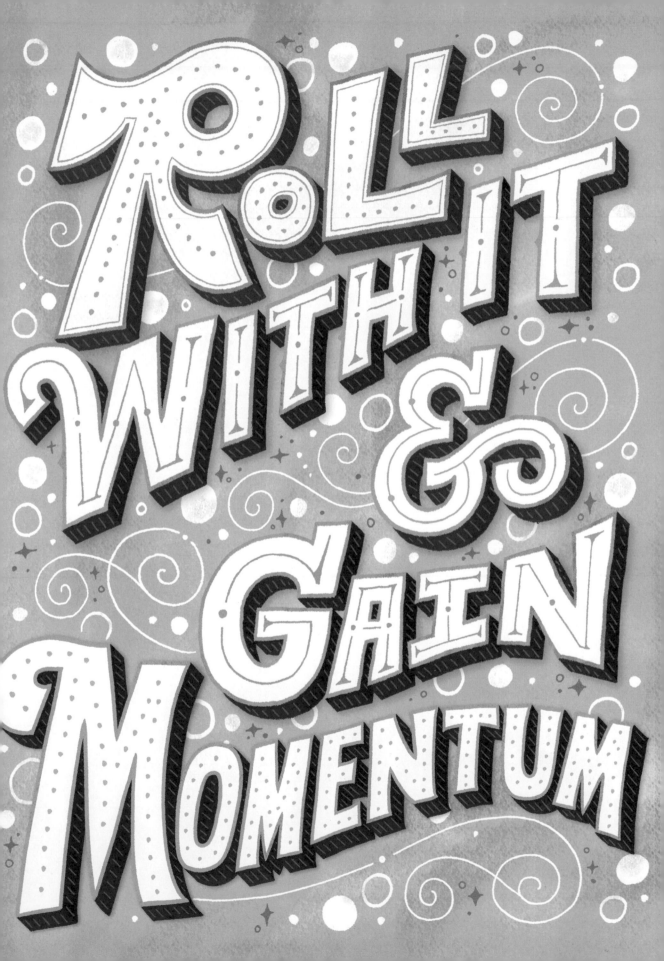

ANDY J. MILLER

YOU ARE INFINITE

In Dr. Carol Dweck's book *Mindset,* she states that there are two types of people in the world: those with a fixed mindset and those with a growth mindset. The fixed mindset sees oneself as unchangeable; you are born with all the personality, intelligence, and potential you will ever have. The growth mindset is the opposite: you can grow in every area of your life. I realized this battle of mindsets in myself before I had ever heard of this book; at some point I realized: If you want to be a great artist, you can't just go with the flow, you have to make waves!

My dad always says "You are infinitely more capable than you think." I've found that when I believe that my potential is infinite and go after what I really want, amazing things can happen. Don't hold onto limiting beliefs about your own potential. Use that energy to gain clarity on what you really want, and go after it.

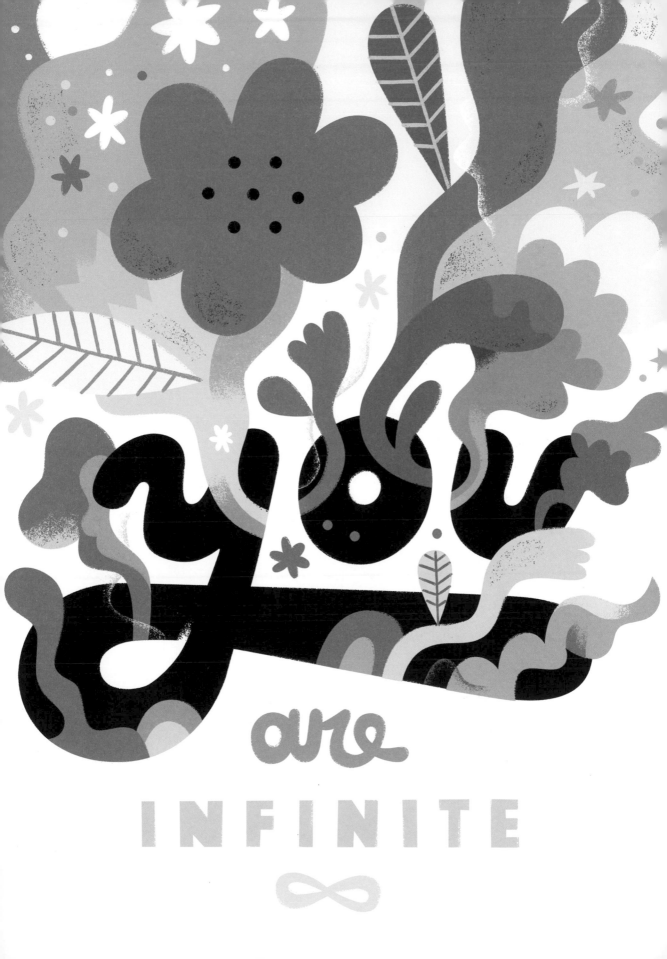

BETWEEN THE CREATIVE AND THE LOGICAL

In an essay I first wrote for Steven Heller's book *Design Disasters: Great Designers, Fabulous Failure, and Lessons Learned*, I reviewed the myriad of failures I'd experienced over the course of my life. I decided to write about my biggest failure of all: the complete lack of belief I had in pursuing my dreams. Over the years, I've expanded the piece into a visual essay for my book *Look Both Ways: Illustrated Essays on the Intersection of Life and Design*, a commencement speech for San Jose State University, and a graphic film for Adobe. I hope this piece resonates with those who fear failing, wonder if they've compromised their own creative dreams for security and stability, or have a hard time choosing magic over logic.

For most of

my life I followed a safe path. I remember in vivid detail the moment I began the journey. August 1983, the hot, muggy summer of "Synchronicity" and "Modern Love." A few months out of college, I stood on the corner of seventh avenue and Bleecker Street in New York City wearing pastel-blue balloon trousers, a hot pink V-neck T-shirt and bright white Capezio Oxfords.

I lingered at

at the intersection peering deep into my future, contemplating the choice between the secure and the uncertain, between the creative and the Logical,

JEN MUSSARI

MAKE FRIENDS, NOT CONTACTS

This was a phrase that kept coming at me in my youth, seemingly ingraining itself into the sensibilities of my entire generation. When I graduated from art school during the most recent economic recession, these words seemed like a desperate lifeline to myself and other young creative types. And while the sentiment is accurate, it also inevitably leads to a certain type of synthetic, networky relationship that I picture "Always-Be-Closing" pinstriped businessmen pushing. I quickly learned that there was a lot to just "knowing" someone. As I met and interacted with fascinating people from all walks of life, generations, and professions, I realized that "who" I knew didn't matter nearly as much as how much we liked each other as people. In the creative industries that often brush up against businessy types, I think it's important to remember the value that real friendliness can bring to these relationships. When we go about the world looking for real friends without any sort of professional agenda, we more naturally build each other up and find success together.

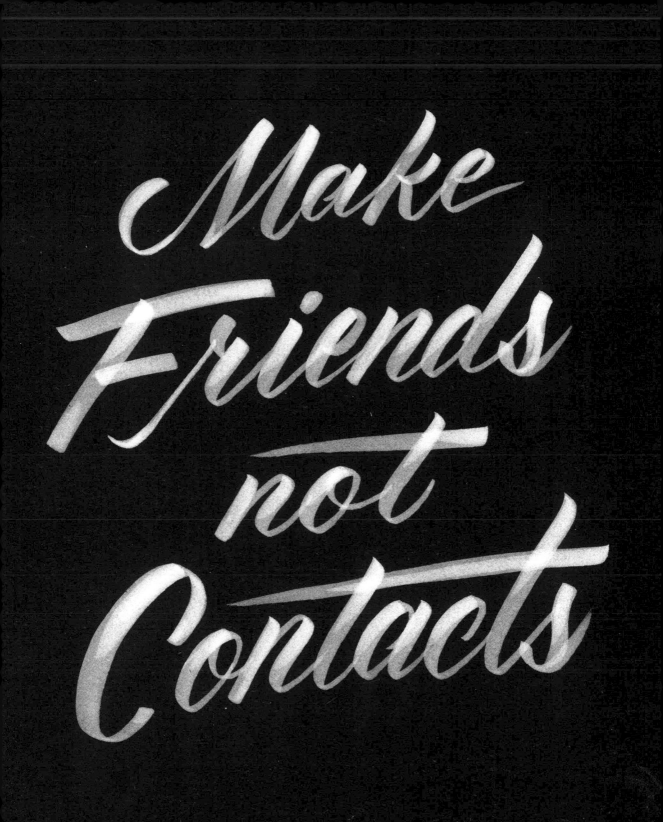

NEASDEN CONTROL CENTRE

IT'S A LONG GAME, TAKE YOUR TIME

A colleague once gave me this advice. I suppose it is along the same lines as the age-old saying that claims that in order to master something, you need to practice it for a minimum of ten thousand hours. This is much debated, as it depends on the quality of the actual practice. Generally, making artwork takes a long time, so it's good practice to allow plenty of time to develop a project. Sometimes you come upon a good idea very quickly but then you need a long time to actually make the piece . . . or vice versa. Some advice is easier to follow than others, but I feel this is a helpful mantra for making good work.

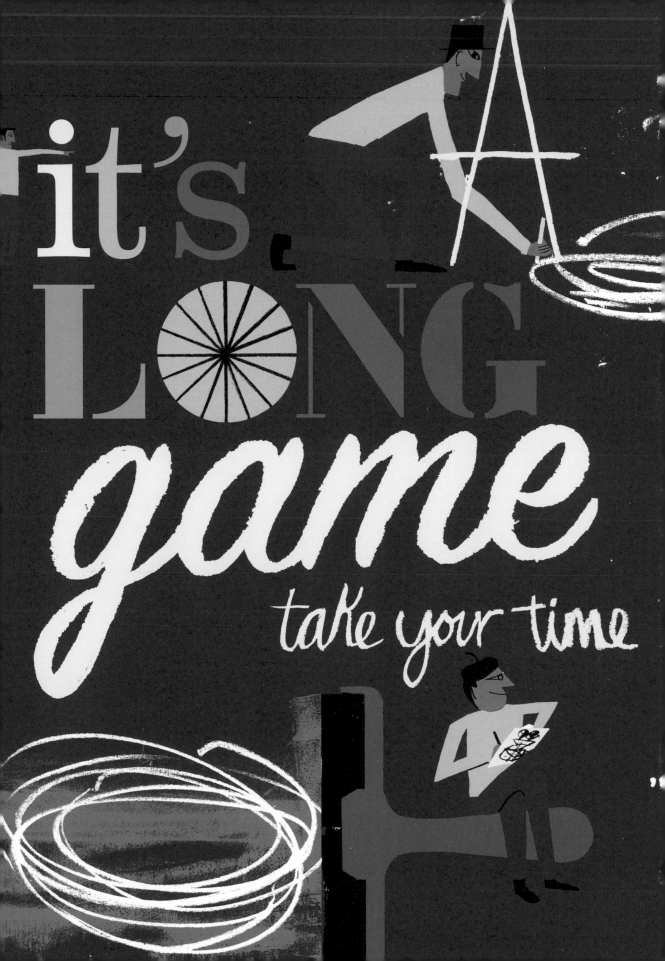

STOP MAKING CENTS

Don't sell yourself short. Too often I would not charge enough for my design time only to later realize *I* was creating the biggest obstacle to my success. If you devalue your contribution to a project, then your clients will do the same. Your work is a custom solution to a client's problem and should be priced accordingly. Make sure to build all of your costs into each project, know your limits, and always overdeliver to maintain clients.

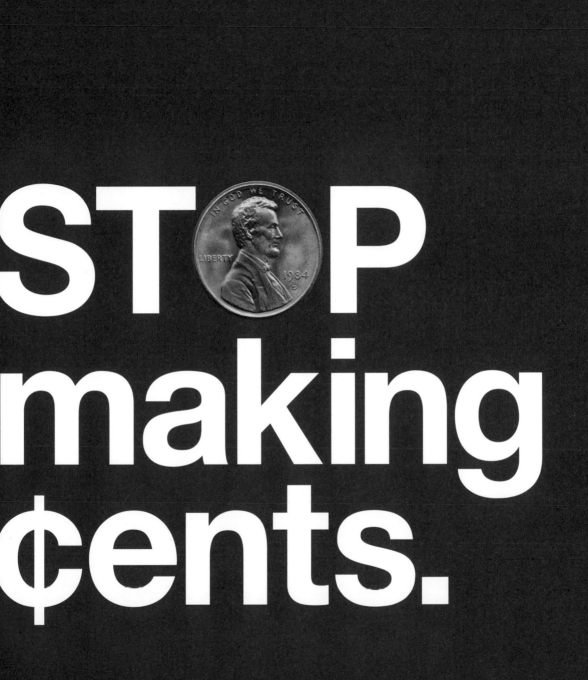

MIKE PERRY

FOLLOW YOUR HEART

Follow your heart. Be ready for the adventure. Work hard. Believe.

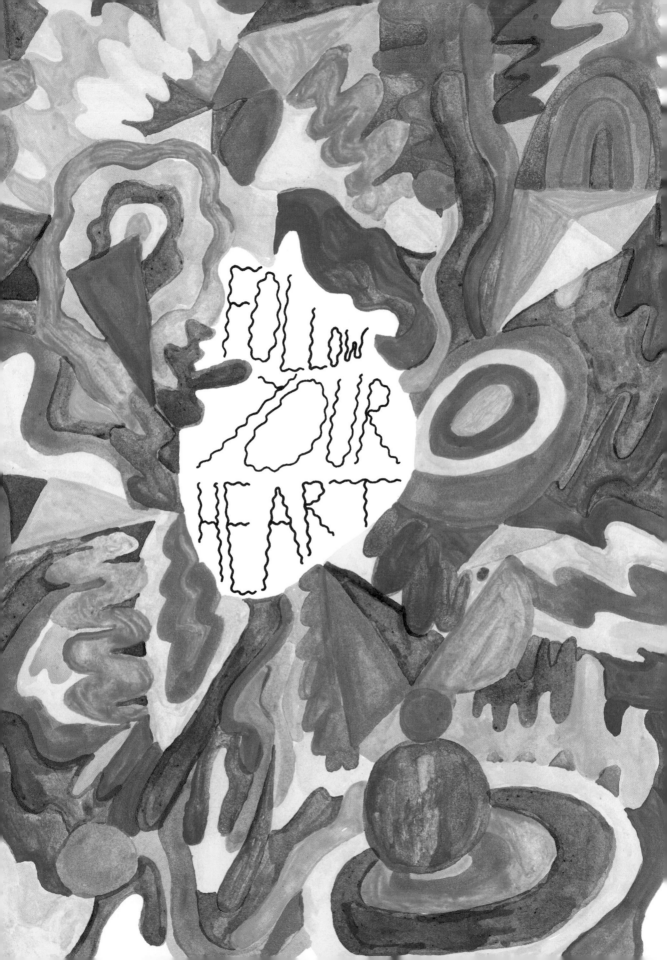

STAY WEIRD

Embracing the things that make me unique has proved to be invaluable throughout my career. Over the years, I've found the work I do that resonates most with my audience (and art directors) is the work I am most passionate about. Any time I've tried to do something that I think might be "marketable," it's usually a flop. So embrace what makes you different and stay weird!

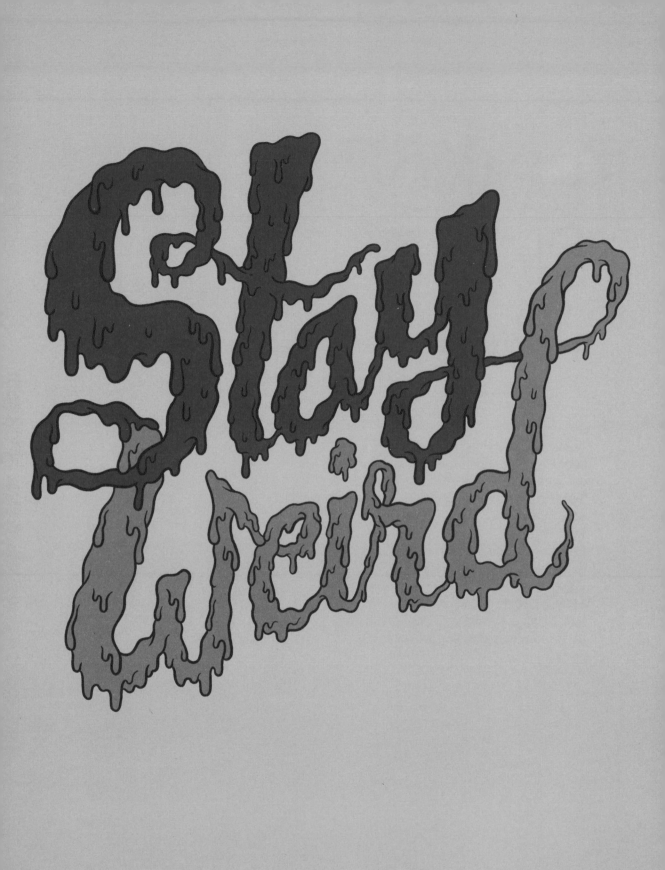

BRANDON RIKE

SPEND YOUR LIFE CREATING SOMETHING

I believe that doing what we love is a fight—an ongoing battle against every influence that wants us to conform. There is no solace in this conformity, only a blurred view of what we set out to be. So it's our job as creatives to do something valuable with our time here, and instead of wasting our life going along with whatever path may have been established for us, we can reconnect with our childlike wonder and imagination and spend our lives creating something.

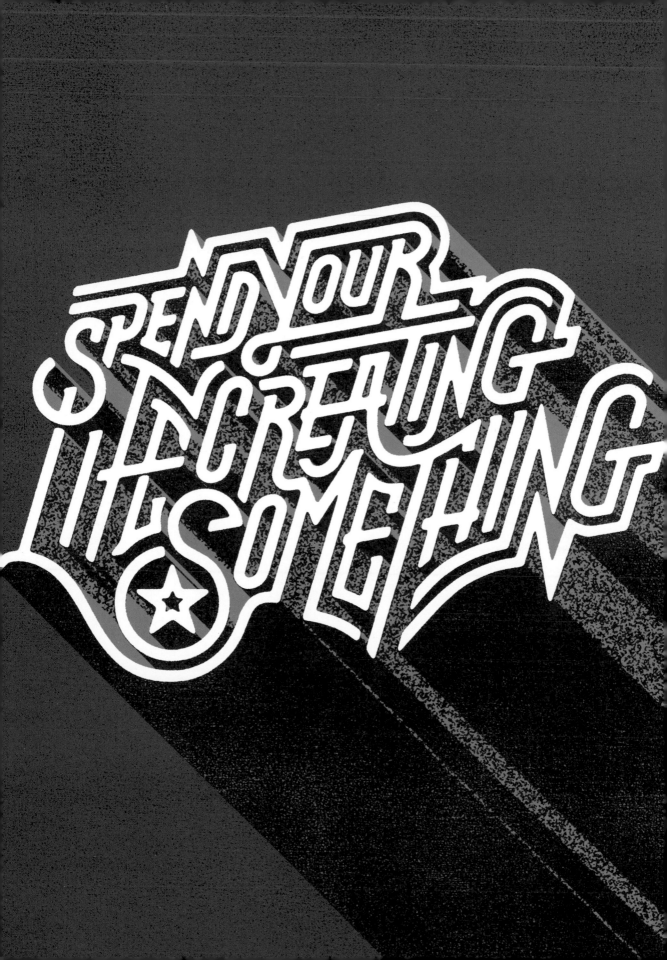

NATHANIEL RUSSELL

TOUCH THE TIP OF YOUR FINGER RIGHT HERE FOR A SECOND AND GET READY TO FEEL THE JUICE!

I made this inspirational poster as part of my time as an artist-in-residence at the Facebook campus in Menlo Park, California. When I think of "the juice," I think of all the invisible forces and energies we feel as humans here on Earth: inspiration, excitement, love, power, confidence, and so on. That magic is real, and it can be conjured and awoken within each of us with practice and patience.

I made this print as a version of an inspirational poster one would find in the workplace. I find the idea of being able to touch the poster for a quick upload of "the juice" very funny but also sort of sad, especially when we realize that the act of touching the poster is to trick us into realizing that "the juice" is already within. It's funny in the way that it makes fun of the pop culture cliché ("the call is coming from INSIDE THE HOUSE!!"); it's sad in the way that after all this time we, as humans, must constantly remind ourselves that we are magic, we can overcome, we can be our true and fulfilled selves.

But it's not too late! As you read this, you can look at the page with the poster printed on it, and you, the reader, can touch the button on the page and feel that "juice" again, any time you need it!

TOUCH THE
TIP OF YOUR
FINGER RIGHT
HERE FOR A
SECOND

↓

AND GET READY
TO FEEL THE

JUICE!

NEWS FLASH:
THE JUICE **HAS BEEN** WITHIN
YOU THE WHOLE TIME!

CHRISTOPHER DAVID RYAN

~~WORK~~ PLAY

"Work" is a four-letter word in more than one sense. Other people "work." I "play." I don't "go to work," I "go to play." I play with lines, shapes, colors, contexts, thoughts, and emotions like a child plays with blocks, dolls, cars, or stuffed animals. I often remind myself of this on those days when the ideas aren't flowing or a client is dragging me down. It's Not Work. It's Play.

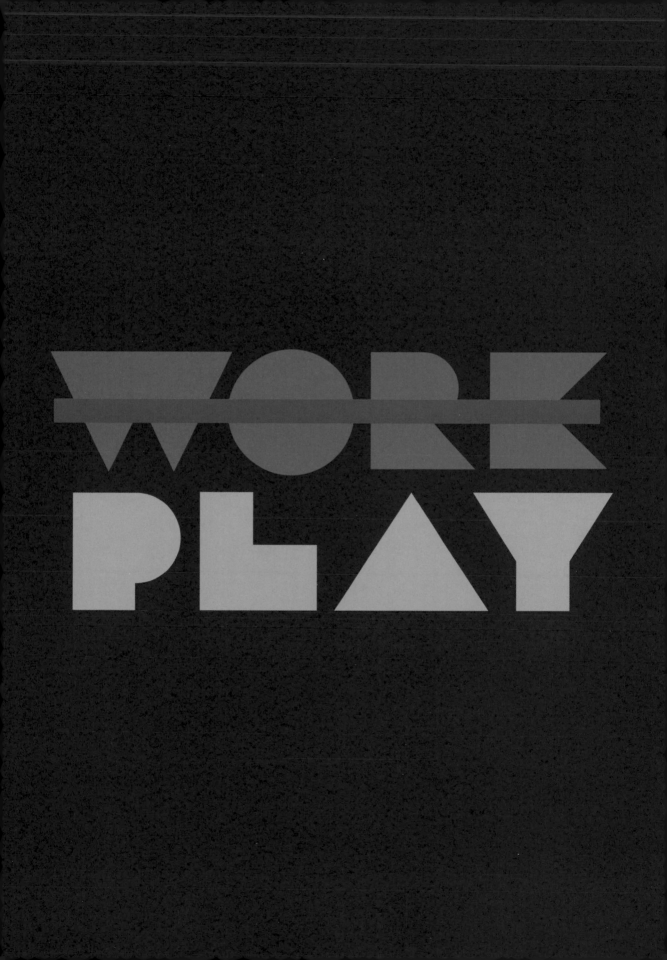

ROB RYAN

I THOUGHT ABOUT IT IN MY HEAD AND I FELT IT IN MY HEART AND I LONGED FOR IT TO HAPPEN WITH ALL OF MY BODY & SOUL BUT I MADE IT WITH MY HANDS

I guess, like everybody else, I spend a whole lot o' time thinking. And thinking and thinking. Boring everyday thoughts, thoughtful thoughts, angry thoughts, paranoid thoughts—so many, many thoughts.

Millions upon millions of invisible words that belong to me and me alone.

I see it as my job as an artist to select some of these thoughts, work with them, and try to mold them into something I want to say. But where do you even start?

So much daydreaming and yearning to sift and sort though; surely it's an impossible task! Then my hands come to my rescue, and if I draw just one line, I can then draw another, and then it begins: thoughts become words, and maybe words become deeds.

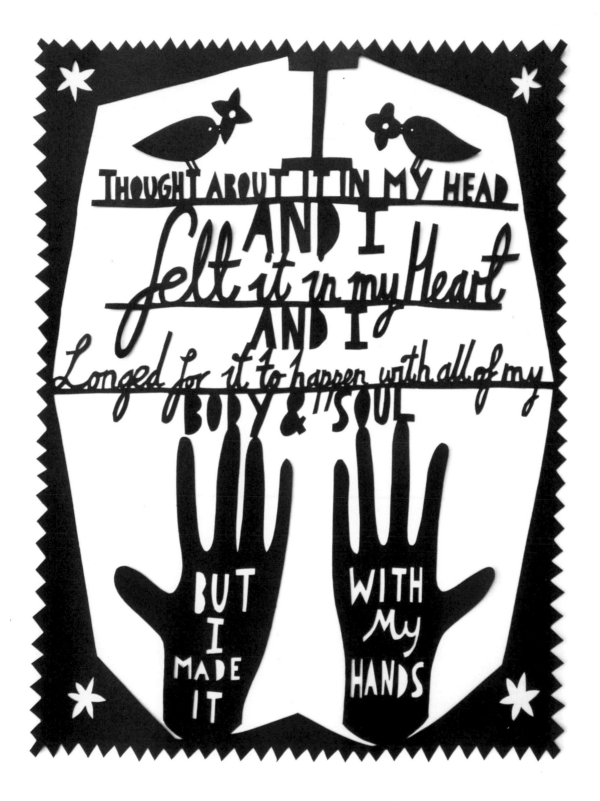

SAGMEISTER & WALSH

TAKE IT ON

This was originally a line from my cognitive therapist who was encouraging me to be less afraid of confrontation.

These posters were created for the School of Visual Arts (SVA) in New York City. We looked around our studio and realized that, as teachers and students, the Sagmeister & Walsh team is rooted in the SVA community. We embraced the maxim by literally taking on the typography on our faces. We worked with renowned photographer Henry Leutwyler and creative retoucher Erik Johansson to achieve this poster series, which was then displayed throughout NYC subway stations.

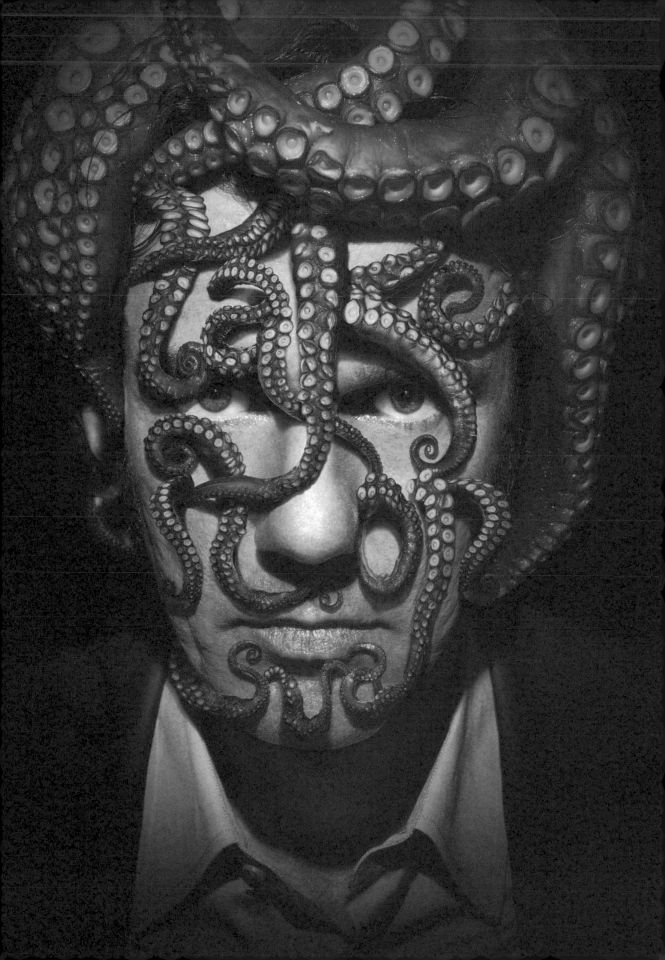

CAROLYN SEWELL

PLEASING EVERYONE IS THE SHORTCUT TO BEIGE

Nobody likes design-by-committee, except maybe the committee. Trying to please every committee member is guaranteed to produce a boring design and an unhappy (and exhausted) designer. The end result is a plain pair of khakis. Nothing offensive, but nothing interesting either. A forgettable piece of beige.

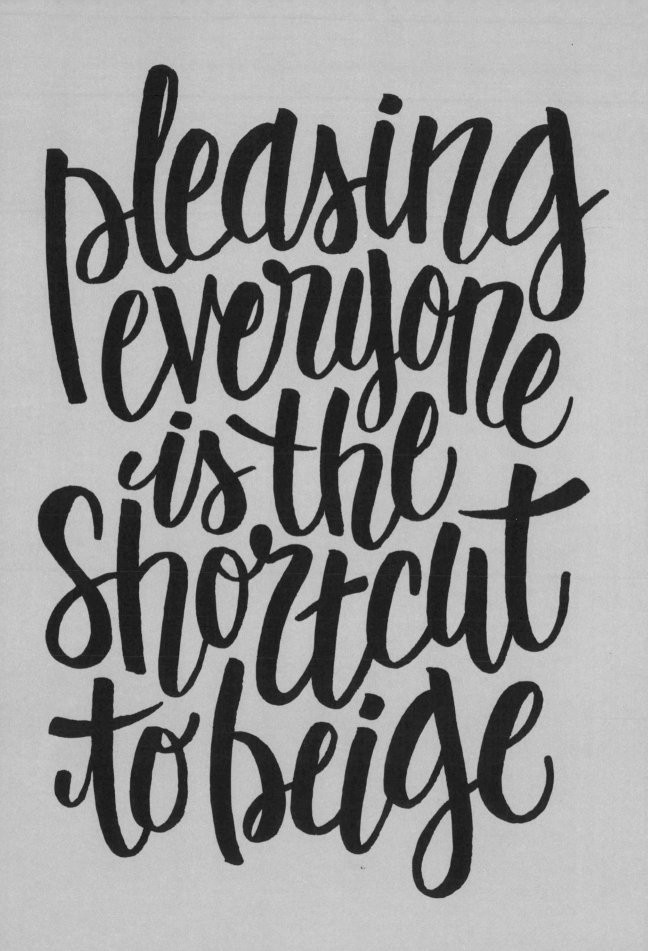

IT'S DONE WHEN IT'S FUN

Keep iterating what you're working on 'til you find that spark in it and make it shine. Whether it be a client project or something you're doing just for yourself, try to bring something fun to it.

It's also about knowing when a piece is done. You can try and try to make something perfect, which is a fool's errand, or you can get something to a place where you are happy with it and let it go. Fun isn't perfect; fun is getting done.

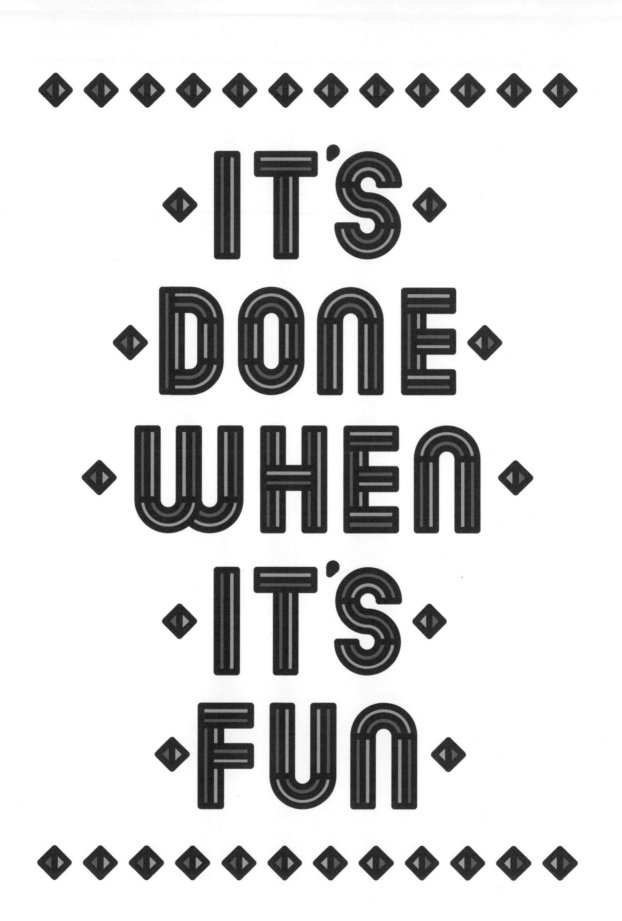

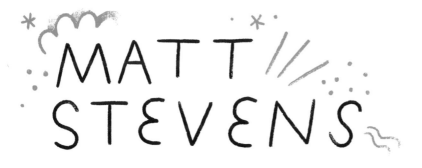

MAKE

I created this personal piece as a large-scale print for clients and friends. It was a simple reminder to stay connected to the core of what we love to do as creatives: to make something personal and valuable. I grew up around brothers and a father who spent a lot of time working on old VWs, and I have a strong affinity for the old automotive manuals and the interesting exploded diagrams they contain. I love exploring letterforms in this style and felt it was an effective language to communicate this idea.

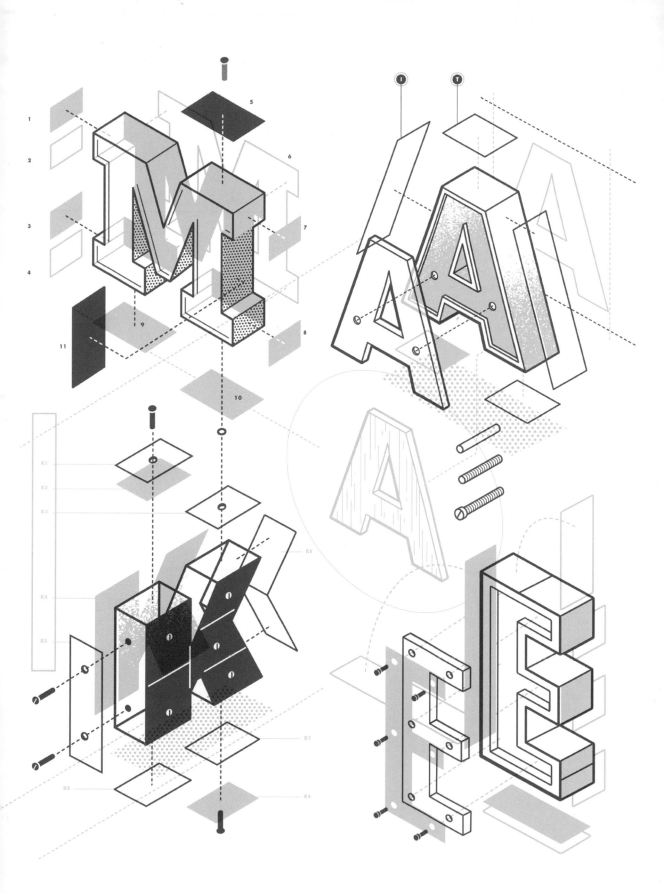

NATE UTESCH

DON'T STOP

It's so very easy as an artist to compare our work to the seemingly prolific amount of polished-gold-nuggets spat out by the creatives who inspire us. We cannot help but compare our behind-the-scenes fumbles and missteps to their relentless home runs. And yet for every gold nugget we see, there are dozens of embarrassing ideas we don't. The old adage, "practice makes perfect," albeit overstated, is maybe not so far from the truth. The people who inspire us the most have certainly worked the hardest.

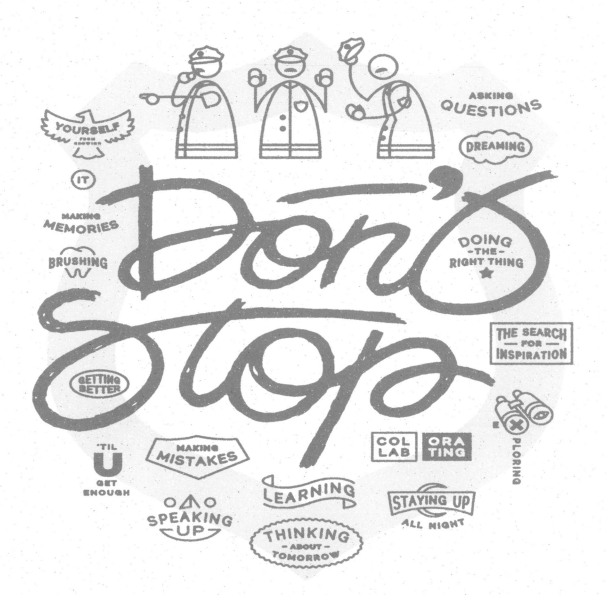

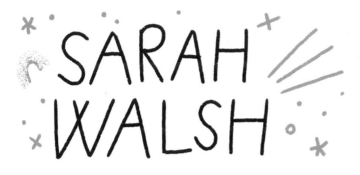

WAKE UP & DREAM

This is sort of like saying "dreaming isn't just for sleeping." I feel like having dreams (goals) is imperative for creatives, or for any human for that matter. Having a dream or goal is something to work toward. Dreams give us a reason to put our best self forward, and from there we get energy. Dreams also give us hope when things aren't going so great. I think the coolest thing about dreams is that we can nurture them and keep them close to our heart 'til they grow big enough to become a reality. That's magic to me.

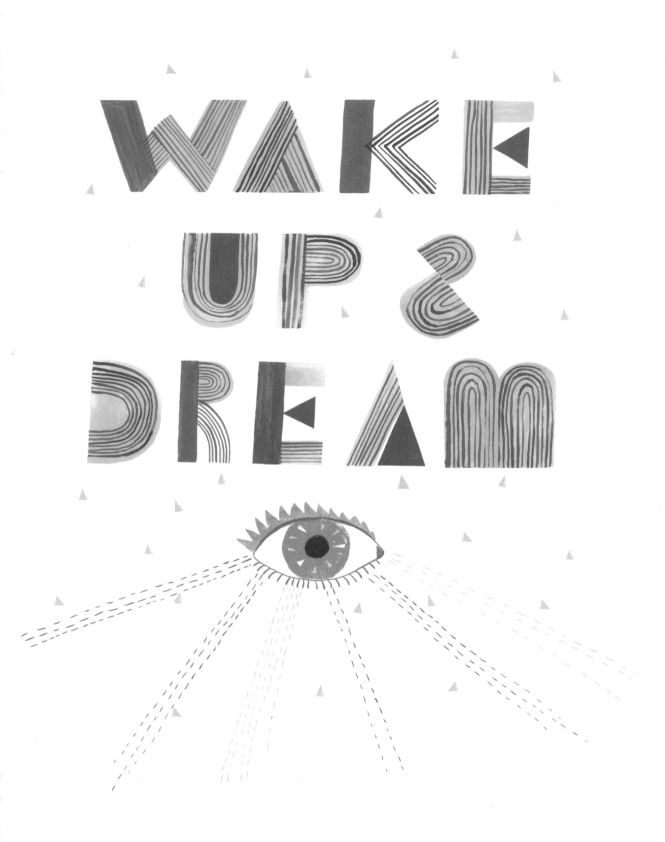

EVERYTHING IS A CYCLE

All of life is organized in a cyclical
way. Just as bodies are broken down
in death by decomposers, every bit
of them transformed into the matter
that nourishes new life, so is the
creative process a constant cycle. All
creative people go through periods of
doubt and discouragement, but those
moments aren't an end. That stage of
dissatisfaction is essential for fueling
the passion to grow, innovate, and keep
challenging ourselves.

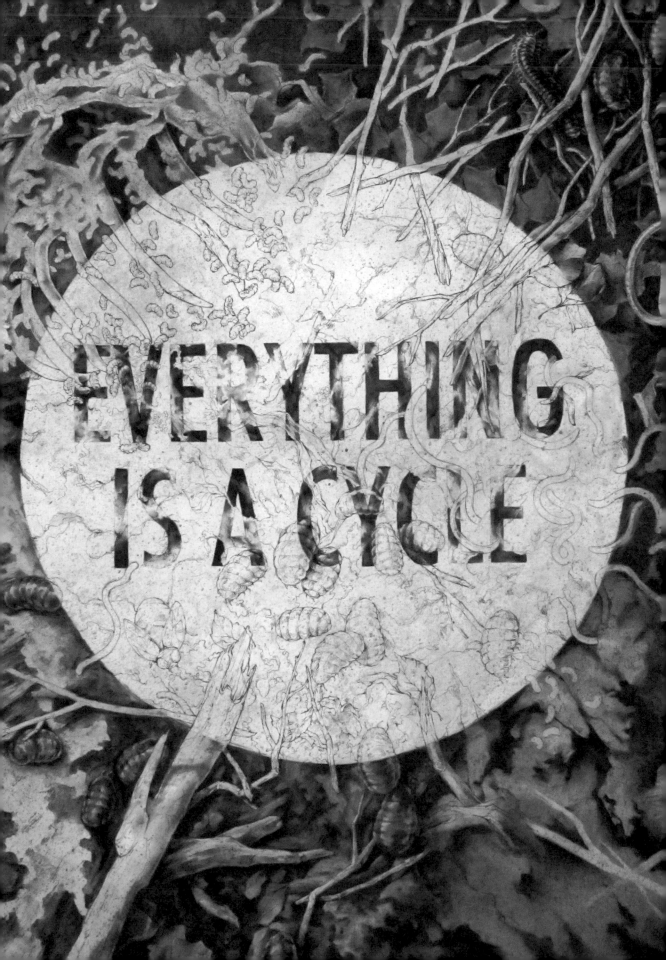

BUILDING SOMEONE ELSE'S DREAM?
PERSPECTIVE IS FREEDOM

These are a series of personal illustrations. The last three years have been really tough on me and my family. When I create personal work, I just listen to music—Dr. James Edward Cleveland, Earl Sweatshirt, Patsy Cline—and let my mind wander. I'm always fascinated how our perspective is almost more important than our reality. As you go through your own hardships, you really learn to become empathetic. You learn that it's not what you have, it's the perspective of what you have (family, love, health, hope, etc.).

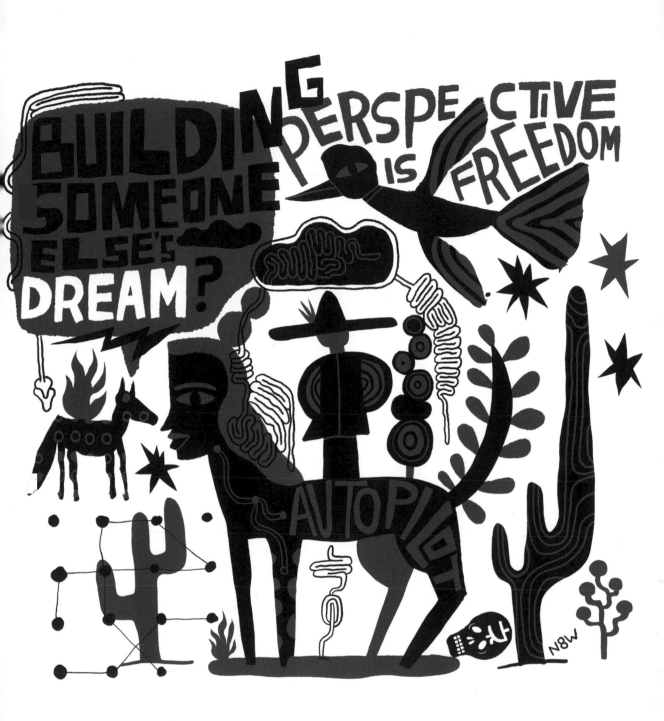

BIO
GRAP
HIES

*

RILLA ALEXANDER

Rilla Alexander is an illustrator and designer whose work has appeared on everything from toys and teacups to buses and buildings. Her cast of characters dance across Museo del Prado's ceramics and stationery, populate Swiss credit cards, and sleep on the walls of a Copenhagen hotel (where she replaced the bed with a tent). Rilla explores the creative process through her alter ego Sozi and her anthropomorphized ideas, using them to inspire both children and adults through picture books and workshops.

ALWAYS WITH HONOR

Always With Honor is the design and illustration studio of Elsa & Tyler Lang. Their work spans the range of branding, illustration, iconography, and environmental design. They have had the opportunity to work with a myriad of clients including the *New York Times*, *Audubon*, XBOX, Microsoft, Nike, and the U.S. Postal Service.

STEVE ALEXANDER

Steve Alexander is a designer, illustrator, educator, artist, and musician exploring the possibilities between the commercial and personal, abstract and literal, superficial and spiritual.

CHUCK ANDERSON

Chuck Anderson is the artist and designer behind NoPattern, a studio he founded in 2003 at the age of eighteen. Over the years, Chuck has lent his vibrant, surreal work to clients such as ESPN, Target, Vans, and Microsoft, among others. Now thirty, he continues to run NoPattern while also acting as the creative director of design at Havas Worldwide Chicago.

KATE BINGAMAN-BURT

Kate Bingaman-Burt's work orbits around the objects in our lives: the things we buy, the things we discard, and the collectivity and social interaction that can arise from cycles of consumption. Via illustrations, daily documentation, publications, events, large-scale participatory projects, client work, and a full-time role as an educator, Kate's work invites a dialogue about contemporary forms of exchange.

DARREN BOOTH

Darren Booth is an award-winning illustrator and lettering artist. His handcrafted, expressive yet controlled, and succinct style has enabled him to collaborate with clients such as Google, Coca-Cola, AOL, Target, McDonald's, and Disney. He's also created his distinctive work for high-profile clients Steve Martin and Willie Nelson.

WILL BRYANT

Will Bryant is an Austin, Texas–based artist. His work weaves together humor with commerce, fun, and positivity. In his sculptural installations, photographic still lifes, and commercial illustration projects, there is always a sense of exuberance at play with a colorful palette.

His work has been plastered across advertising campaigns, T-shirts, record sleeves, posters, magazines, furniture, snowboards, and underwear, and also exhibited internationally. In 2013, he was named a Young Gun by the Art Directors Club.

When not working, he enjoys hanging out with his daughter and wife, reading about sports, shooting hoops, or lounging in expensive sweatpants.

BUILD

Build is a design studio, specializing in creating visual languages and identities for clients through art direction, graphic design, image making, moving image, and typography. By mixing bold design with wit and thinking, Build gives form to ideas, from dynamic to playful.

JON BURGERMAN

Jon Burgerman is a European artist currently painting, writing, animating, and performing in New York City.

He is known for his colorful characters, goofy humor, and Kool-Aid-cubist compositions.

As well as entertaining with his work, he also encourages creativity and play in his audience, using the mantra "It's Great to Create."

TAD CARPENTER

Tad Carpenter is a designer, illustrator, author, and educator based in Kansas City, Missouri. Tad co-runs the design and branding studio Carpenter Collective with his wife, Jessica, where they focus on bringing powerful messages to life through branding, packaging, illustration, and design. They have worked with clients that include Target, Coca-Cola, Macy's, Old Navy, Conan O'Brien, Adobe, and MTV, among many others.

Carpenter Collective has worked with numerous bands on poster campaigns for more than ten years, as well as writing and illustrating over a dozen children's books in the marketplace today. Tad also teaches graphic design at the University of Kansas.

MIKEY BURTON

Mikey Burton is a part-time designer and a part-time illustrator—which adds up to a full-time Designy Illustrator. He's been working professionally for more than twelve years now, but claims to be "still figuring it out." He's done a lot of work in that time for clients such as Converse, ESPN, Target, the *New York Times*, *TIME* magazine, and *Esquire*, among others. He spent his formative years and earned a master's degree from the great Kent State University in Ohio. Mikey now works and lives in Brooklyn, New York, where he pays way too much for coffee.

DAN CASSARO

Dan Cassaro is a designer and illustrator working in Brooklyn, New York. He is the founder of twelve different temporary tattoo companies, CEO of HorseTinder, and the first man to have sex with a brand. He ain't a beauty, but, hey, he's alright. Dan lives with his wife and pet snakes in a converted 3D printer.

DAN CHRISTOFFERSON

Dan Christofferson is the founder and sole member of two different (very successful) secret societies.

JON CONTINO

New York native Jon Contino is widely known for his uniquely distinct style. Handy with pen and paper, he's scribbled and sketched for companies like Nike, 20th Century Fox, Ford, American Eagle, and Jack Daniel's. In the last two decades, his work has appeared on magazine covers, shirts, album jackets, and national ad campaigns. In addition to running his studio, Jon is founder and creative director of Contino Brand menswear, cofounder and creative director of CXXVI Clothing Company, and brand manager for Past Lives. He lives in New York with his wife, Erin, and their daughter, Fiona.

LISA CONGDON

Portland illustrator Lisa Congdon is best known for her colorful paintings, intricate line drawings, pattern design, and hand lettering. She works for clients around the globe including MoMA, Harvard University, Airbnb, Chronicle Books, and Random House, among others. Lisa is the author of six books, including starving-artist-myth-smashing *Art, Inc.: The Essential Guide to Building Your Career as an Artist*, and illustrated books *The Joy of Swimming*; *Fortune Favors the Brave*; *Whatever You Are, Be a Good One*; *Twenty Ways to Draw a Tulip;* and *A Collection a Day*. She was named one of 40 Women Over 40 to Watch in 2015.

HELEN DARDIK

Helen Dardik is a professional illustrator and a surface-pattern designer based in Canada. Vibrant, folksy, playful toomuchery is a perfect way to describe her style. Born by the Black Sea, Helen lived in Siberia for a time and then moved to Israel, where she studied art and design. In the early nineties, she relocated to Canada, where she got a graphic design degree and found work as a designer and illustrator.

Helen mainly works in vector, using the magic of imagination combined with the magic of Adobe Illustrator . . . but, often, watercolor, oil, gouache, embroidery, and vinyl find their way into her repertoire. Finding inspiration in her childhood, her three little girls, nature, vintage books, and midcentury design, Helen is determined to make her life into the most creative experience.

AARON JAMES DRAPLIN

Located in the mighty Pacific Northwest, the Draplin Design Co. proudly rolls up its sleeves on a number of projects related to the identity, print, illustration, and Gocco muscle categories. They pride themselves on a high level of craftmanship and quality that keeps them up late into the wet Portland night.

JOEY ELLIS

Joey Ellis works as character illustrator for brands, games, and stories of all kinds. He lives in Charlotte, North Carolina, with his wife, Erin, and two boys, James and Michael.

DANIELLE EVANS/ MARMALADE BLEUE

Danielle Evans is a visual punner and lettering artist from Columbus, Ohio. In 2013, she combined lettering, photography, and dad jokes to start a food typography studio, Marmalade Bleue, and continues to blaze the niche's breadcrumb trails. Her work is a clever marriage of design and artful arrangement— approachable, tongue-in-cheeky, and hailed internationally as a visual feast.

Danielle's work has grown beyond edible goods to plants, wearables, and everyday objects; she embraces the strangest visual challenges with optimism and has probably oiled more lobsters than you. Her clients include Target, Disney, American Greetings, Aria, TAZO, Tesco, Bath & Body Works, Cadillac, the *Guardian*, and Kellogg.

BOB EWING

Bob Ewing is a father, husband, art director, and letterer based in Indianapolis, Indiana.

ADAM R. GARCIA/ THE PRESSURE

The Pressure is a multidisciplinary creative studio based in Portland, Oregon. The studio's work spans aesthetic in the fields of design, identities, direction, illustration, event coordination, gallery exhibits, and packaging design. The studio's conceptual and process-driven approach creates solutions with a focus on collaboration, community, and creative exploration.

DANIEL FISHEL

Daniel Fishel is an illustrator from the Keystone State but resides in Queens, New York. He's been nominated as one of *Print Magazine*'s New Visual Artists: 15 Under 30 and has worked with the *New York Times*, the *Washington Post*, *GQ* magazine, McSweeney's, and NPR. He has a tortoiseshell cat named Avocado and eats a lot of tiramisu.

TIMOTHY GOODMAN

Timothy Goodman is a designer, illustrator, and author running his own studio in New York City. His clients include Airbnb, Google, Adobe, Ford, J.Crew, Target, the *New Yorker*, and the *New York Times*. He has received awards from most major design and illustration publications. He graduated from the School of Visual Arts in New York, where he now teaches. Timothy cocreated the blog and book *40 Days of Dating* that has received fifteen million unique visitors. His writing series, "Memories of a Girl I Never Knew," exhibited at Colette in Paris, France. His second book, *Sharpie Art Workshop*, is out now.

ROB HODGSON

Rob was born in a seaside town in the south of England in 1988. He currently lives in Bristol, England, where he spends his days making a mess and turning it into illustration projects and books. Some interests include cats, skateboards, the Beach Boys, the psychology of perception, and collecting weird toys. His first children's book, *The Cave*, will be out in 2017.

ERIN JANG

Erin Jang is a designer and illustrator living in New York City. She worked as a magazine art director for many years at *Esquire*, *Martha Stewart Living*, and several other publications. She now runs her own design and illustration studio, The Indigo Bunting, creating work for clients such as Chronicle Books, the *New York Times Magazine*, *Wired*, *Lucky Peach*, Disney, Paperless Post, and Land of Nod. She is also the author of *Make & Give*, a modern, design-driven craft book.

MEG HUNT

Meg Hunt is an illustrator and maker of things. When she's not reading, exploring, or teaching students, Meg is always in search of ways of pushing herself in new directions. Her clients have included Chronicle Books, Adobe, Storey Publishing, Disney, Plansponsor, Red Cap Cards, Coach, Dreamworks, and Scholastic.

OLIVER JEFFERS

Oliver Jeffers is a visual artist and author working in illustration, painting, collage, and sculpture. His critically acclaimed picture books have been released internationally and translated into more than thirty languages, and his artwork has been exhibited at institutions including the Brooklyn Museum in New York City, the Irish Museum of Modern Art in Dublin, and the National Portrait Gallery in London. Oliver grew up in Belfast, Northern Ireland; he currently lives and works in Brooklyn, New York.

JOLBY & FRIENDS

Jolby & Friends is a multidisciplinary creative studio building meaningful and thoughtful experiences through collaboration.

Josh Kenyon & Colby Nichols (Jolby) began their partnership in 2005 taking on freelance work outside their agency art director day jobs. In 2010, the two decided to open their own studio that quickly grew in scope and creativity. The team that emerged is built on the original foundation of putting oneself aside in order to create the best collaborative work possible.

ERIK MARINOVICH

Erik Marinovich is a San Francisco–based lettering artist and is a cofounder of Friends of Type. He has drawn letters, logos, and type for a series of nice folks since 2009. In 2012, he cofounded Title Case, a creative work space that conducts workshops and lectures. Between client work, teaching, and side-projects, you'll find him playing Lego with his children, Luka and Zara.

LITTLE FRIENDS
OF PRINTMAKING

Husband-and-wife team JW and Melissa Buchanan first made a name for themselves by designing and printing silkscreened concert posters but soon branched out into further fields, designing fancy junk for whoever would pay them money. In addition to their work as illustrators and designers, they continue their fine art pursuits through exhibitions, lectures, and artists' residencies worldwide, spreading the gospel of silkscreen to anyone inclined to listen. The Little Friends currently live in Los Angeles with too many animals.

MARY KATE MCDEVITT

Mary Kate McDevitt is a lettering artist, occasional author, illustrator, and teacher living and working in Philadelphia, Pennsylvania. Since 2010, Mary Kate has worked with a variety of clients including Chronicle Books, Nike, and Target.

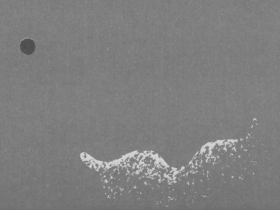

ANDY J. MILLER

Andy J. Miller is a full-time freelance illustrator with a background in graphic design, currently living and working in Columbus, Ohio.

Andy was born in Indiana, went to middle school in western New York, to high school in Indiana, and to the University of Huddersfield in the United Kingdom. He is best known for his projects and books: The Indie Rock Coloring Book, the collaborative Color Me _____ exhibit with Andrew Neyer, the daily drawing project NOD, and his Creative Pep Talk podcast.

JEN MUSSARI

Jack of all trades. Master of a couple. Lettering artist, illustrator, fine artist, designer, community member, dog sitter (prefers cats), collector of things, Tattly artist, sign painter, etc. Proud Philadelphian, left her heart in Baltimore, had a quick love/hate fling with San Francisco, now in the nurturing arms of Brooklyn.

Some of the clients she is proud to have collaborated with include Squarespace, Airbnb, Kickstarter, Shopify, Patagonia, the Art Directors Club, EMI, Capitol Records, Target, West Elm, Penguin Books, Adobe, LOGAN, Pentagram, 72andSunny, CreativeMornings, and Smilebooth.

DEBBIE MILLMAN

Debbie Millman is CMO of Sterling Brands, President-Emeritus of AIGA, chair of the School of Visual Arts' master's program in branding, editorial director of *Print* magazine and host of the award-winning podcast "Design Matters." She is the author of six books.

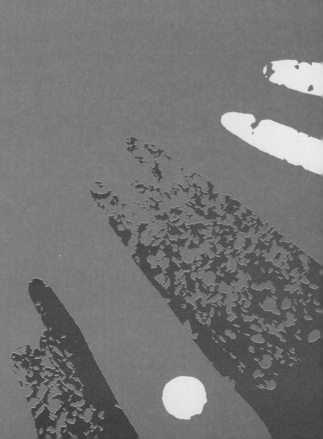

NEASDEN
CONTROL CENTRE

Stephen Smith is an illustrator who has been working under the studio name of Neasden Control Centre since 2000 and whose work encompasses a range of hand-drawn illustration commissions and installation projects. He has exhibited his artwork and installations internationally (Baltic Centre for Contemporary Art, Mu, Nam June Paik Centre) and regularly releases print editions. He has also published his work in monographic books with Gestalten, as well as contributing to a range of group publications such as *The Age of Collage Art*, *Contemporary Collage in Modern Art*.

MIKE PERRY

Mike Perry is an artist, animator, creative director, brand consultant, poet, and designer. His work encompasses paintings, drawings, sculptures, art installations, books, and murals, all of which are made to conjure that feeling of soul soaring you have when you stare into distant galaxies on a dark night, when you go on long journeys into the imagination, and when you laugh and can't stop laughing. Key to Mike's working method is the recognition that art and objects go through many iterations—discoveries, coverings, uncoverings—until they're finished; people do the same until they are fully revealed. He likes to cultivate collectives of celebration, exhibition, and revelation.

ANDREW NEYER

Andrew Neyer is an American artist and designer. He received his BFA in printmaking from Maryland Institute College of Art in 2008.

His products are simple, sculptural, useful, familiar, and extraordinary.

CHRIS PIASCIK

After starting his career as a graphic designer at award-winning studios in New England, Chris accidentally became an illustrator. He's pretty happy about that. This strange transformation was a result of his daily drawing project that he started in 2007; in fact he's still posting a new drawing every day. In addition to those drawings, he makes other drawings for clients like Coca-Cola, Nike, Ogilvy, and Nickelodeon. Chris received his MFA in illustration and BFA in Graphic Design from the University of Hartford's Hartford Art School, where he is currently an adjunct professor.

NATHANIEL RUSSELL

Nathaniel Russell was born and raised in Indianapolis, Indiana. After college, Russell spent several years in the San Francisco Bay Area, making posters, record covers, and woodcuts. He returned to his home city of Indianapolis and now spends his time creating drawings, fake fliers, bad sculptures, wood shapes, and music. Nathaniel's work is regularly shown around the world in both traditional galleries and informal spaces, usually surrounded by an expanding list of friends, collaborators, and like-minded folk. He frequently returns to his second home of California to work with friends on projects as varied as murals, print workshops, and backyard musical performances.

BRANDON RIKE

Brandon Rike is a freelance graphic artist in the music merchandising industry. With a client list that reads like a lineup for the mother of all music festivals, he has created work for a vast array of clients and styles, honing his lettering, design, and illustration skills along the way. With more than a decade of experience, Brandon shows no signs of stopping and continues to be passionate about what he can apply his creativity to and how he can inspire other creatives.

CHRISTOPHER DAVID RYAN

Christopher David Ryan (CDR) makes art constantly, sometimes quite literally covering the walls with the narrative of his hyperactive imagination. His characters embrace, they reach out to one another, and they reflect the small truths of daily life—sometimes with irony but never with sarcasm. A cosmic enthusiast and deep thinker, CDR literally tries to make the world better through art, promoting peace and love in vibrant color and without self-censure.

CDR is a partner at More & Co., produces spacey soundscapes under the name Symbolized, and sometimes designs as his alter ego Atmostheory. He makes his home in Portland, Maine.

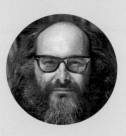

ROB RYAN

Rob Ryan was born in 1962 in Akrotiri, Cyprus. He studied fine art at Trent Polytechnic in Nottingham, England, and at the Royal College of Art, London, where he specialized in printmaking.

Known for his intricate paper cuts, his work adapts itself readily to screen printing, which can be easily transferred to ceramics, fabrics, and other surfaces.

He has collaborated with the likes of Paul Smith, Liberty of London, Tatty Devine, and *Vogue*.

He readily admits that his work, which often consists of whimsical figures paired with sentimental, grave, honest, and occasionally humorous pieces of writing, is autobiographical.

He lives and works in London.

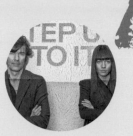

SAGMEISTER & WALSH

Sagmeister & Walsh is a design company in New York City. They have worked for clients as different as the Rolling Stones, the Guggenheim Museum, and Levis. Exhibitions on their work have been mounted in New York, Philadelphia, Tokyo, Osaka, Seoul, Paris, Lausanne, Zurich, Vienna, Prague, Cologne, and Berlin.

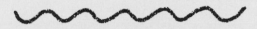

CAROLYN SEWELL

Carolyn Sewell is a letterer and illustrator living in the metro DC area. A potty-mouthed lover of all things typographic and unicorny, she creates work that is lovely, irreverent, and shiny. Extremely happy, but never satisfied, Carolyn collects passion projects like others collect stamps. Her year-long project of daily-drawn "Postcards To My Parents" pivoted her career from graphic design to hand lettering. Since then, her work has been published in *Communication Arts*, *PRINT*, *Grafik*, *HOW*, *CMYK*, and the *Washington Post*. Lesson learned: draw something every day and be nice to your folks.

SKINNY SHIPS

Skinny Ships is the illustration and design tag team of Richard Perez and Jennifer DeRosa. After meeting in college, the two worked side-by-side as freelancers for a couple of years before finally joining forces. Now with their combined talents, they aim to create work that is deceptively simple yet fun, charming, and captivating.

They have collaborated on projects for Google, Facebook, IBM, and a whole lot of other very nice folks. Currently the two work out of their home studio in Portland, Oregon, where they are surrounded by a collection of vinyl records, books, and cat hair.

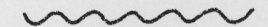

MATT STEVENS

Matt Stevens is a designer and illustrator from North Carolina whose focus is brand identity and illustration. He has done work for big brands you've heard of and small brands you have not and gets the most joy from partnering with clients to create experiences that are thoughtful and unforgettable and present a unique point of view.

NATE UTESCH

Nate Utesch is half of the art department at Secretly Group (record labels Dead Oceans, Jagjaguwar, Secretly Canadian), makes electronic music as Metavari, and is cofounder of the small-press publisher Ferocious Art & Fiction.

TEAGAN WHITE

Teagan White is a Minnesota-based freelance illustrator specializing in intricate drawings of flora and fauna, playful watercolors of animal characters, and illustrated typography. Her clients have included Target, Papyrus, American Greetings, Penguin Random House, Nike, *Wired* magazine, and the *Washington Post*, and she has illustrated two picture books, *Adventures with Barefoot Critters* and *Bunny Roo, I Love You*.

SARAH WALSH

As a little girl, Sarah was obsessed with drawing, wearing animal costumes, making dioramas, and daydreaming about magical creatures. She later went to art school in upstate New York and then worked at Hallmark Cards as an in-house designer/illustrator. Upon acceptance into the Lilla Rogers Studio, Sarah decided it was time to try freelance illustration. She loves mid-century design, hand lettering, folk art, vintage children's books, music, and world culture. Sarah has two children and is married to fellow illustrator Colin Walsh. Their joint project is Tigersheep Friends.

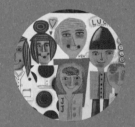

NATE WILLIAMS

Nate Williams is an art director, designer, author, artist, and cofounder of radiCOOLS. In a nutshell, he creates images and ideas and encourages curious kids and playful adults to discover the world through curiosity, play, and art.

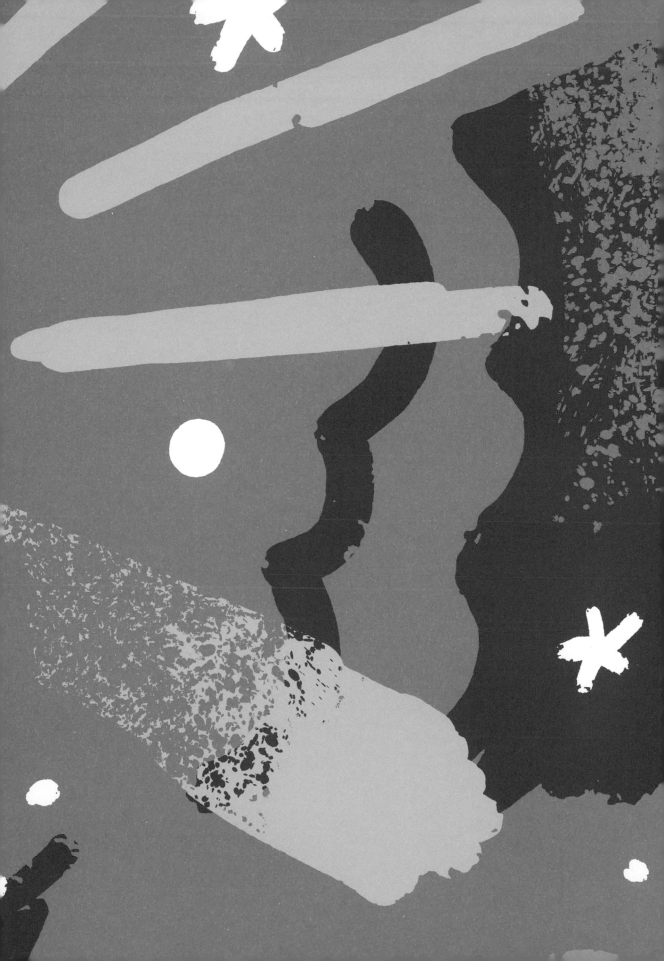